PAINTING IN FOCUS

# Caspar David Friedrich

## WINTER LANDSCAPE

John Leighton
and Colin J. Bailey

Exhibition organised
by John Leighton

The National Gallery, London
28 March – 28 May 1990

First published in Great Britain in 1990 by
National Gallery Publications Limited
5/6 Pall Mall East, London SW1Y 5BA

British Library Cataloguing in Publication Data
Leighton, John, 1959-
Caspar David Friedrich, Winter landscape. – (Painting in
focus).
1. German paintings. Friedrich, Caspar David
I. Title    II. Bailey, Colin J., 1946–    III. National
Gallery. Great Britain    IV. Series
759.3

ISBN 0-947645-75-6

Designed by Harry Green
Typeset by Wyvern Typesetting Ltd, Bristol
Printed and bound in Great Britain by
White Dove Press Ltd

COVER: Detail from *Winter Landscape* by
Caspar David Friedrich, National Gallery, London

# Contents

# Acknowledgements

The original idea for this exhibition developed from conversations with colleagues in the Museum für Kunst und Kulturgeschichte in Dortmund and I would like to thank Wolfgang E. Weick and Kurt Wettengl of the Dortmund Museum for their support and collaboration.

Inevitably, problems with the condition of some of Friedrich's early works have resulted in some regrettable gaps in our exhibition but these have been more than compensated for by the generosity of the institutions and private owner who have lent the works in their care. Of the many museum directors and curators who have assisted with this project I would like to express particular thanks to the following: Hubert Adolph, Rolf Andree, Götz Czymmek, Werner Hofmann, Jürgen Julier, Michael Krapf, Helmut Leppien, Hans Albert Peters, Anke Quester, Eckhard Schaar, Werner Schmidt, Werner Schubert, Peter Wegmann, Jon Whiteley and Horst Zimmermann.

I owe a special debt of gratitude to the co-author of this catalogue, Colin J. Bailey of Edinburgh College of Art. His knowledge of Friedrich has informed every stage of the project and his enthusiasm and dedicated scholarship have been a constant inspiration. Other Friedrich scholars have been generous with their expertise and I wish to thank in particular, William Vaughan, Hans Joachim Neidhardt, and Helmut Börsch-Supan, who first attributed the *Winter Landscape* to Friedrich and who has since provided invaluable advice.

My thanks also to: Jack Baer, Dieter Gleisberg, Harry Green, Ralph Haugwitz, Gerald Kaspar, Gillian Keay, Andrew Kellard, Kurt Meissner, Heidemarie Otto, Lise Renne, Manfred Rudolphe, Ingo Sandner, Fritz Schäfer, Carl and Norah Schwab, Alistair Smith, Hans Strutz, Paul Tolstoy and Hermann Zschoche.

Within the National Gallery the support and assistance of the following members of staff are gratefully acknowledged: Karen Bath, Peter Brett and the working party, Aviva Burnstock, Sue Curnow, Herb Gillman, Sara Hattrick, Jo Kent, Joan Lane, Jean Liddiard, Felicity Luard, Neil MacGregor, Jacqui McComish, Carol McFadyen, Anthony Reeve, Margaret Stewart, Joe Swift, Hugo Swire, Michael Wilson and Louise Woodroff. The exhibition was designed by Communication by Design.

JOHN LEIGHTON

# Foreword

In December 1987, the Trustees of the National Gallery bought at auction in Monaco Caspar David Friedrich's *Winter Landscape*. The picture had come to public attention only shortly before, although a celebrated version of the composition has hung for many years in the Museum für Kunst und Kulturgeschichte in Dortmund. On arrival in London the newly acquired painting was cleaned. This small exhibition examines it in depth for the first time.

The collection of the National Gallery is rich in so many areas that most new acquisitions, like the recent Van Dyck or Cuyp, build on what is already formidable strength. The *Winter Landscape* by Caspar David Friedrich is different. It is the first of his paintings to enter any British public collection. And in Trafalgar Square, as indeed in the country as a whole, it remains the only distinguished representative of the whole school of German Romantic painting. This exhibition therefore celebrates not only the arrival of a small inwardly beautiful landscape, but, we hope, a further step in the growing public enjoyment of German nineteenth-century art.

British neglect of Germany nineteenth-century painting is perhaps not surprising. Most German painters of the last century found ready patrons at home, so few chose or needed to export their works during their lifetime. This century's wars ensured that no British connoisseur would buy Menzel or Runge in the way Keynes or Courtauld bought Cézanne and the Impressionists. To these practical obstacles were added theoretical ones. Critics concerned primarily to investigate art as a formal progression from Cézanne through Cubism to full Abstraction were unlikely to linger on the spiritual narrative of artists like Friedrich, whose formal repertoire owes a great deal to earlier art and whose contribution to the European tradition is as much in his content as in his handling of it.

It is that content which is principally explored in this catalogue. Generous loans allow Friedrich's growing belief in the inherent divinity of nature to be traced from his first works to paintings, like the *Winter Landscape*, of his early maturity. If its pendant in the Schwerin Museum is sadly not in the exhibition, that loss is to some extent made good by the magnanimous loan from Dortmund of the other version of the *Winter Landscape*, previously the only one known and long deemed the undisputed original. The public will be able to compare both versions, and decide their relative status for themselves.

Our debts of gratitude are many: to National Gallery Publications, whose profits, in a time of frozen purchase grants, made this acquisition possible; to the many individuals and institutions who have kindly lent paintings and drawings; to William Vaughan, who pioneered the rediscovery of Friedrich in this country; to Colin J. Bailey for his learned contribution to the catalogue; and to John Leighton, the Curator of nineteenth-century paintings. Finally, we wish to acknowledge a special debt to Mr Gert-Rudolf Flick for his generous support, so unhesitatingly given. On behalf of all who work at the National Gallery, our warmest thanks.

NEIL MACGREGOR, *Director*

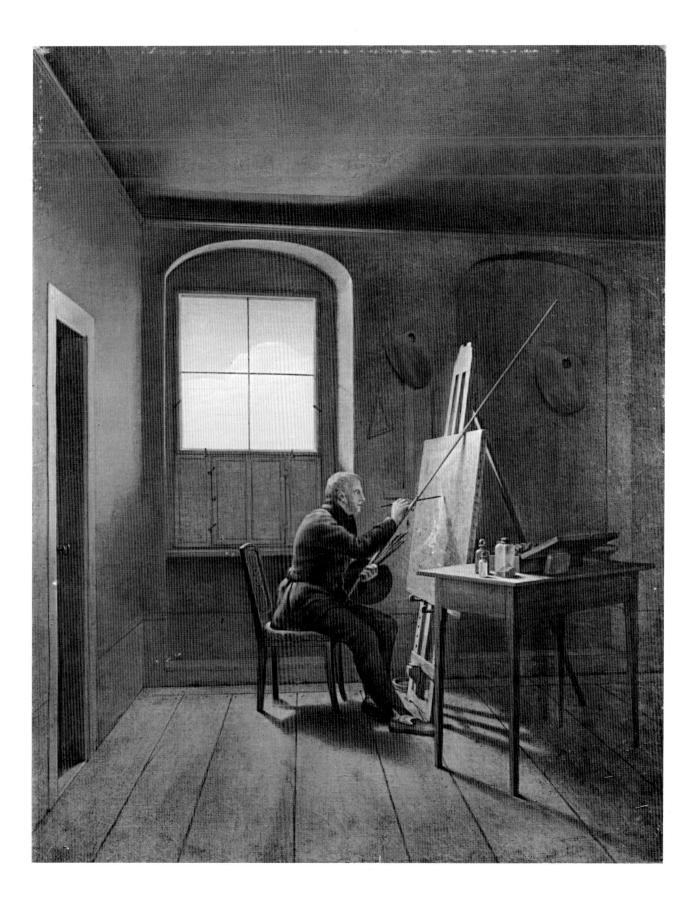

# Caspar David Friedrich
# An Introduction

## COLIN J. BAILEY

In the ninety-five years since his rediscovery by the Norwegian art historian Andreas Aubert,[1] Caspar David Friedrich has received increasingly favourable critical attention. After decades of neglect his work was first restored to public notice in 1906 in Berlin, when more than thirty of his paintings were included in the *Deutsche Jahrhundert-Ausstellung*, a mammoth exhibition reviewing the most important achievements in German art during the period from 1775 to 1875. His full rehabilitation was accomplished in 1972 by the Tate Gallery retrospective, which was followed two years later by large-scale bicentennial exhibitions in Hamburg and Dresden that unequivo-cally established his international reputation.[2] Today, Friedrich is rightly regarded as a central figure in the German Romantic movement, and as one of the most individual and uncompromising artists of his genera-tion, whose contribution to nineteenth-century Euro-pean landscape painting ranks in importance with that of his English contemporaries Constable and Turner. At a time when German art and society were in the thrall of revolutionary change, Friedrich made a decisive break with the fashions and conventions of his day by abandoning the picturesque landscape tradition, in which he had been trained, and sought a new pictorial idiom which would allow him to express symbolically his deeply held religious and political beliefs and at the same time convey the intensity of his emotional response to nature.

At the end of the eighteenth century, and for the first few years of the nineteenth, two distinct land-scape traditions prevailed in Germany. The first, best exemplified by Jacob Philipp Hackert (Fig. 1), was a modification of the formula established by Claude, and typically was devoted to the depiction of idealised Italianate landscapes with simple staffage figures or scenes from classical mythology. The second, which was more naturalistic and empirical, was principally inspired by seventeenth-century Dutch painting, and in particular by the work of Jacob van Ruisdael, whose influence is plainly visible in pictures by artists such as Johann Christian Klengel (Fig. 2). In certain respects Friedrich remained indebted throughout his life to both these traditions, but he was not content, as were many of his compatriots, simply to perpetuate the jaded formulae of the past, and was openly critical of those who did.[3] Apart from devising a radically new formal language for his paintings, what particularly

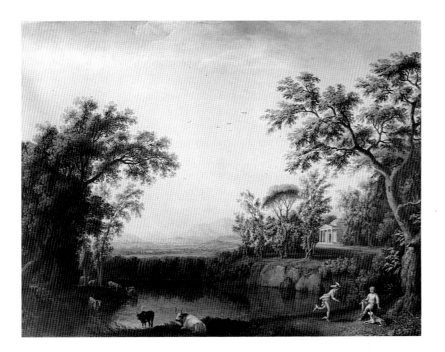

7

distinguishes Friedrich from other German artists of his generation is the intimate communion he needed with nature in order to produce the effects he desired. In 1821 he wrote to his friend Zhukovsky: 'I must surrender to what surrounds me, unite myself with my clouds and rocks in order to be what I am. I need solitude in my communication with nature.'[4]

Friedrich held typically Romantic views regarding artistic inspiration. For him, the study of nature and the old masters was only a preliminary to what was essentially a subjective creative process. In his view, the artist should always listen carefully to the dictates of his heart and be governed primarily by his feelings. 'The artist's feeling is his law,' he wrote, 'Pure sensations can never be in contradiction to nature, but only in agreement with her.'[5] Elsewhere he declared, 'The only true source of art is our heart, the language of the pure and innocent soul. A painting that does not have its genesis there can only be vain sleight of hand.'[6] As he was concerned to make clear, his aim was not primarily to depict nature realistically:

> It is not the faithful representation of air, water, rocks and trees, which is the task of the artist, but the reflection of his soul and emotion in these objects. . . . The artist should not only paint what he sees before him, but also what he sees within him. If, however, he sees nothing within him, then he should desist from painting what he sees before him. Otherwise his pictures will resemble those folding screens behind which one expects to find the sick or even the dead.[7]

There is an element of the visionary here, of course, and the powerful spiritual resonances his works evoke are an expression of this personal inner vision. Friedrich began his pictures only after a long period of silent meditation, and he expected them – in much the same way as poetry or music – to 'react on others from the outside inwards'.[8] Carl Gustav Carus, who was intrigued to discover something about the artist's working methods, states in his autobiography that Friedrich 'never began a painting until it stood lifelike in his imagination,' and that 'his pictures in every phase of their development gave a definite, well-ordered impression of his personality and of the mood which had originally inspired them.'[9]

In his landscapes Friedrich concentrated on the more melancholic aspects of nature. The French sculptor David d'Angers, who visited him in Dresden in 1834, is reported to have said of him: 'Voilà un homme qui a découvert la tragédie du paysage.'[10] Friedrich's palette is admittedly often sombre, espe-

cially in some of his earlier works, but he later developed a sense for exquisite colour harmonies which enabled him to produce pictures of ineffable beauty and unprecedented emotional power.

Among his contemporaries, Heinrich von Kleist and Carl Gustav Carus were virtually alone in fully appreciating the modernity and originality of his art.

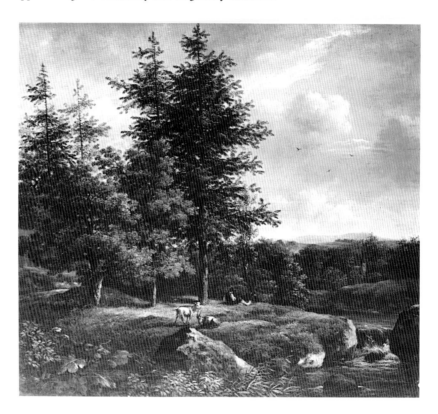

Carus wrote a perceptive tribute in an obituary notice published in *Kunstblatt* shortly after Friedrich's death, in which he acknowledged the artist's historical significance and his unique contribution to German landscape painting. It opened with the following observation:

> Anyone who goes back five or six decades in the history of landscape painting, particularly in Germany, will come upon a somewhat dismal state of affairs. . . . After the ideas of Ruisdael, Everdingen, and Waterloo on the one hand and those of Claude Lorraine, the Poussins, Salvator Rosa, and Swanefeldt on the other had been elaborated in increasingly duller fashion . . . a kind of landscape painting gained ground which could only really be described as superior wallpaper painting. A few dark, mannered trees on either side of the foreground; some ruins of ancient temples or a mass of rock nearby; then

Fig. 2 Johann Christian Klengel, *Landscape near Dresden*, 52 × 59 cm, Gemäldegalerie Alte Meister, Dresden

in the middle distance a few staffage figures on horseback or on foot, wherever possible with a river and a bridge and some cattle; a stretch of blue mountains beyond; and several pleasing little clouds above – this is approximately what passed at that time as a 'landscape'.[11]

In Carus's estimation, Friedrich had done more than anyone else to salvage the reputation of landscape painting in Germany and, by dint of his energy and genius, was responsible for transforming a genre that had become hackneyed and prosaic into something vital, poetic and inspirational. But in his valediction there lay a tragic irony: Friedrich died in poverty and obscurity, and more than sixty years elapsed before his memory was revived.

Friedrich was born in 1774 in the small Baltic seaport of Greifswald, where his father, a staunch Lutheran Protestant, had established a prosperous business as a soapboiler and candlemaker. Having shown early signs of an interest in art, at the age of sixteen he was enrolled as a private pupil of the university drawing master, Johann Gottfried Quistorp, with whom he studied for the next four years. He learned principally by copying from Quistorp's extensive collection of paintings and engravings and from various practical drawing manuals placed at his disposal, such as Johann Daniel Preissler's *Die durch Theorie erfundene Practic*. Towards the end of this period, presumably under his teacher's direct supervision, he also experimented fleetingly with etching, a medium to which he returned in 1799/1800. Quistorp's role in Friedrich's development was crucial for, as well as imparting the rudiments of drawing, on their walks together in the Pomeranian countryside he instilled in him a love of the vast expanses of the north German landscape, and awakened his interest in local historical and prehistoric sites, like the ubiquitous cairns and the abbey of Eldena, which provided him with motifs that formed part of his permanent pictorial repertory.

At this time Friedrich may also have made the acquaintance of Quistorp's friend, Gotthard Ludwig Kosegarten, a disciple of the poet Friedrich Gottlieb Klopstock. As provost of Altenkirchen on the Baltic island of Rügen, Kosegarten preached the emotional piety of the Enlightenment and in his open-air sermons explained various natural phenomena as divine revelations.[12] Kosegarten's pantheism was the cornerstone of his literary activities, and his religious interpretation of nature, as it emerges in his poetry, closely resembles Friedrich's belief in an omnipotent and omnipresent divinity.[13] Kosegarten's range of imagery is particularly interesting, for the ancient oak groves, moonlit Nordic landscapes and heathen burial sites, to which he frequently refers in his poems, have the same symbolic importance as Friedrich's pictorial counterparts. Poet and painter were above all united in their conviction that as artists they were endowed with rare gifts enabling them to communicate hidden truths and to mediate between God and mankind through feeling and intuition rather than by intellectual reason. In this Friedrich's ideas were also very similar to those of the German Romantic poet Novalis, who believed in a secret continuity between the visible and the invisible.

In 1794, probably on Quistorp's personal recommendation, Friedrich left Greifswald in order to continue his studies at the academy in Copenhagen. This would have been a natural choice, for strong mercantile links had long existed between the German Baltic ports and the Danish capital and it had become semi-traditional for young north German artists to train there. Asmus Jacob Carstens, the great Neo-classical painter from Schleswig, had been a student in Copenhagen from 1776 to 1783, and Philipp Otto Runge from Wolgast and Georg Friedrich Kersting from Güstrow also followed in his footsteps. At the end of the eighteenth century the Copenhagen Academy, modelled closely on that of Paris, was generally acknowledged to be one of the finest in Europe, on a par with the academies in Berlin, Dresden and Vienna. Though it had the reputation of being ultra-conservative, students were exceptionally fortunate in the quality of their professors, many of whom were men of wide experience and distinction. They also enjoyed the privilege of being permitted to study in the Royal Picture Gallery, which housed an especially fine collection of Dutch seventeenth-century landscape and marine paintings by artists that included Ludolf Bakhuysen, Allart van Everdingen, Jan van Goyen, Aert van der Neer, Jacob van Ruisdael and Simon de Vlieger. Importantly, in view of Friedrich's somewhat precarious financial situation, since 1771 tuition had been provided free of charge, and foreigners as well as Danish scholars were eligible for gold medals and other major prizes.[14]

As a bastion of Neo-classicism, the Copenhagen Academy inculcated in its students a belief in the absolute supremacy of drawing. After elementary drawing lessons, they were required to practise freehand drawing, followed by the antique class, and, finally, drawing from life. Anatomy and ornament, as well as the more theoretical aspects of geometry and perspective, were also taught, and lectures were

delivered covering mythology and aspects of the history of art.[15] No instruction in oil painting was included in the curriculum, however, and students wishing to paint needed to negotiate separately with the professors in order to gain admission to their

In October 1796 Friedrich transferred to the antique class, where for more than a year he copied from the academy's renowned collection of plaster casts, before being allowed to proceed in January 1798 to the life class, where he was taught in turn by

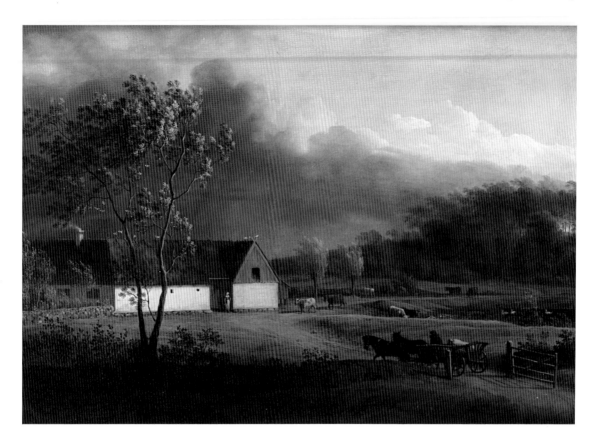

Fig. 3 Jens Juel, *Zealand Farm with an Approaching Storm*, 43 × 61 cm, Statens Museum, Copenhagen

studios. Friedrich's great strengths as a draughtsman and the fact that he was over thirty before he seriously turned his hand to oils are directly attributable to the nature of the system of which he was both product and critic. Much of his time in the elementary class was spent copying engravings after sixteenth- and seventeenth-century masters, and in this respect – though it undoubtedly broadened his knowledge of European styles – his initial training at the academy can have differed little from the tuition he had already received under Quistorp. Graduation to the next class signified only marginal progression, for freehand drawing at Copenhagen meant merely the copying, under instruction, of original drawings by other artists. However, since the specimens provided included works by past and present professors of the academy, it was probably at this stage that Friedrich first saw drawings by Jens Juel, who was to have a decisive influence on his early career.

the sculptors Andreas Weidenhaupt and Johannes Wiedewelt, and by the painter Nicolai Abraham Abildgaard.[16] As the most eminent practising history painter to whom Friedrich had direct access, Abildgaard – though notoriously aloof in his dealings with students – was nevertheless the teacher whose example he is most likely to have followed when he briefly essayed literary subjects. Friedrich's sepia composition of 1799 illustrating a scene from Schiller's *Sturm und Drang* drama *Die Räuber* (Museum der Stadt, Griefswald) is reminiscent in several respects of paintings by Abilgaard, including those on Shakespearian themes such as *Hamlet*, in the Kunstmuseum in Aarhus. Both are dominated by abnormally attenuated figures, whose gestures and expressions are accentuated by the artists' similar deployment of dramatic light. Abilgaard also left his mark on Friedrich's early drawing style, in particular on the manner in which he depicted figures. The clearest

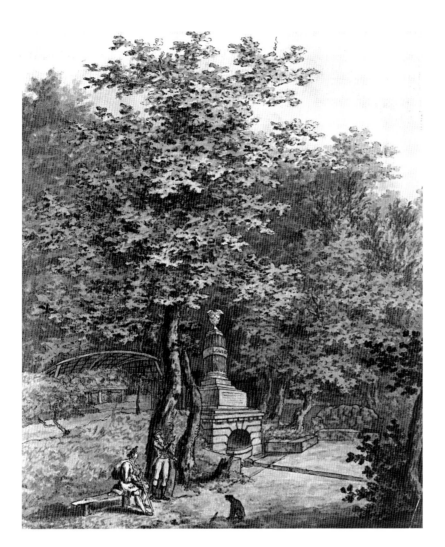

Fig. 4 Caspar David
Friedrich, *The Luise
Fountain at Frederiksdahl*,
pen, ink and watercolour,
28.9 × 24.4 cm,
Kunsthalle, Hamburg

evidence of this is provided by drawings of 1801 from the dismembered Mannheim Sketchbook, where Friedrich's method of defining form by precise linear outlines in pen and ink overlaid by simple monochrome washes closely parallels Abildgaard's practice in figure drawing.

The artist from whose teaching Friedrich derived the greatest lasting benefit, however, was Jens Juel, the most successful Danish portraitist of his generation and a landscape painter of rare ability. The precedence given to history painting over all other genres throughout Europe at this time in no sense denoted the neglect of landscape painting at the academy in Copenhagen, where it was arguably more highly regarded than in any comparable institution. Several distinguished landscape painters taught there, and in 1794, the year of Friedrich's arrival in the city, landscapes by Juel, Christian August Lorentzen and the late Erik Pauelsen featured prominently

in the academy exhibition. Juel had been trained in Hamburg in the traditions of seventeenth-century Dutch painting, and his early landscapes clearly owe much to his study of Aert van der Neer, which doubtless explains his lifelong preoccupation with poetic effects of light. A typical painting, of the kind with which Friedrich is likely to have been familiar, is Juel's *Zealand Farm with an Approaching Storm*, in the Statens Museum, Copenhagen (Fig. 3). Juel brought to such landscapes a freshness of vision that revitalised old pictorial formulae. Endowed with extraordinary acuity of observation and equal sensitivity to the nuances of colour, through his use of delicate glazes he was able to achieve memorable and evocative atmospheric effects that foreshadow Friedrich's own mature works and anticipate more generally the *Stimmungslandschaften* (landscapes of mood) of the Romantics. Juel's influence on Friedrich was both immediate and enduring, manifesting itself at once in the way in which he set about recording botanical information in his drawings. Whereas formerly Friedrich's representation of plants and trees had been perfunctory, from 1797 onwards, following Juel's example, he drew almost exclusively from nature and described his subjects with such minute attention to detail that they are immediately identifiable by their species.

While Friedrich's decision to become a professional landscape painter was probably not made until after he had left Denmark, watercolours produced while he was still a student testify to his early interest in the subject as well as to his aptitude for it. The most fascinating and accomplished of these is a series dating from 1797, apparently made outdoors, depicting springs and fountains in the countryside around Copenhagen. Though essentially topographic and patently inspired by contemporary fashions in Danish landscape gardening, their real importance, at least so far as Friedrich's future development is concerned, lies in the fact that while still in his early twenties he seems already to have been thinking of landscape in allegorical terms. This is demonstrably so in the Hamburg *Luise Fountain at Frederiksdahl* (Fig. 4), where the focus of our attention is a monument erected to the memory of Luise Schulin by her sister, the owner of Frederiksdahl. Here the figure of a man pointing to her memorial disturbs the idyllic mood of the landscape and lends the picture the unmistakable character of an *et in arcadia ego*.

Another of Friedrich's watercolours executed about the same time records an eighteenth-century pavilion near Klampenborg, a few miles north of the

Danish capital (Fig. 5). The contrast between the straw-roofed shelter in the foreground, with a dying tree beside it, and the elegant pavilion set amid luxuriant vegetation has predisposed some to interpret the subject as an allusion to the poverty of our earthly existence compared with the enchantments of paradise, while others construe it as a more straight-forward reference to the plight of the poor in an age of ostentatious elegance. Interpretations of both kinds, however, may be premature, for such imagery was part of the stock repertoire of the European pictures-que tradition, and many other artists at this time, including Juel himself, made use of exactly similar motifs with apparently no intention of making political or eschatological statements. Stylistically, these watercolours demonstrate the extent to which Friedrich was indebted to local landscape traditions but we know surprisingly little about his training in this regard. It is generally assumed that he studied landscape painting under Juel and Lorentzen, whose influence is evident in many of his early works, but his intimate knowledge of landscape composition and his use of certain current pictorial conventions may have as much to do with the fact that he was employed during his spare time by the engraver Georg Haas to hand-colour prints after Lorentzen and Pauelsen.[17]

After four years at the academy, Friedrich left Copenhagen in 1798 and settled permanently in Dresden, which he was later to describe as 'the German Florence'. The Dresden Picture Gallery afforded him his first proper opportunity to study paintings of the finest quality by artists of all the major European schools, and the value of the lessons he learned there is evident in the many landscape compositions he produced based on Dutch seven-teenth-century prototypes. The Saxon capital was then also the centre of the German Romantic movement and home to many of its most illustrious writers and philosophers, among them Novalis, Jean Paul, Schelling, the Schlegels, and Steffens. Before long Friedrich had made the personal acquaintance of Gotthilf Heinrich von Schubert and Ludwig Tieck (to whom he was introduced by Runge), and he remained in close contact with Dresden literary circles until the end of his life. Shortly after his arrival he presented himself at the Dresden Academy, where, seemingly conscious of certain deficiencies in his previous artistic training, he sought out artists such as Adrian Zingg and Johann Philipp Veith. Though he was never a student of either in any formal relationship, he closely modelled his style on theirs and copied their landscape compositions (Cat. 5).

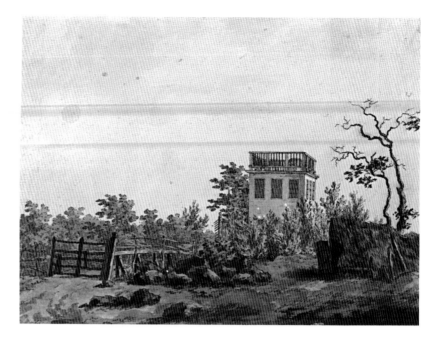

Friedrich earned his living to begin with as a conventional topographical artist working mainly in pen and ink or gouache. The turning point in his career came in 1802 following an eighteen-month stay in his native Greifswald and two visits to the neighbouring island of Rügen. On his return to Dresden, equipped with sketches from his tour, he began producing views that were entirely different in character from any he had done before, and which for the first time bore the stamp of his individual artistic personality. Long before he was acclaimed as a painter in oils Friedrich established a substantial reputation in Germany with large sepia compositions based on his recent experiences of Rügen. Among these was *Cape Arkona at Sunrise* (Cat. 3), the biggest in a series of sepias depicting the headland in varying atmospheric conditions: in stormy weather, by moon-light, and at twilight. The view in each, based on the same drawing of 22 June 1801 in the Large Rügen Sketchbook, is from the seashore near Vitt looking towards the cape at the north-eastern tip of the island. In his choice of subject and general approach Friedrich evinced close affinities with others. In his *Lieder an Rugard* Kosegarten had observed the correspondence between man's moods and the changing aspects of the headland, and in 1771, in his *Allgemeine Theorie der schönen Künste*, Johann Georg Sulzer had actually advocated painting the same scene many times over under different effects of light in precisely the way that Friedrich chose to do:

It would be an interesting experiment to have a

Fig. 5 Caspar David Friedrich, *Landscape with Pavilion*, pen, ink and watercolour, 16.5 × 22 cm, Kunsthalle, Hamburg

talented landscape painter render a scene under twenty different effects of light and cloud, but always from exactly the same vantage point. . . . A landscape which at one hour of the day can seem quite flat under certain light conditions . . . can at other times strike one as quite magnificent.[18]

In 1803 two of Friedrich's Rügen landscapes were purchased by Runge, who patently considered them a good investment.[19] Shortly afterwards Kosegarten bought three or four others 'with views of Arkona and Stubbenkammer'.[20] But the most encouraging tribute to Friedrich's achievements in this medium came in 1805 when he submitted two large sepia compositions, *Summer Landscape with a Dead Oak Tree* and *Procession at Dawn* (Staatliche Kunstsammlungen, Weimar) to the seventh of the annual competitions organised by the *Weimarer Kunstfreunde*, Goethe and Johann Heinrich Meyer. The purpose of these competitions was to encourage German artists to treat historical subjects in the grand manner (as Reynolds had attempted to do in Britain in his *Discourses*), and the theme in 1805 was officially prescribed as 'The Labours of Hercules'. Despite disregarding the rules of the competition by entering two landscapes, Friedrich so impressed the jurors that Goethe and Meyer divided the first prize between him and Joseph Hoffmann from Cologne, and warmly commended his efforts in the *Jenaische Allgemeine Literatur-Zeitung*.[21] It was Friedrich's first major public success. In his letter of thanks to Goethe, written on 14 December 1805, he offered him the sepias as a gift, which Goethe accepted, presenting them afterwards to Duke Karl August of Weimar. Goethe's receipt of the drawings inaugurated their friendship, and on 18 September 1810 he honoured Friedrich with a visit to his Dresden studio.

The technique of painting in sepia (derived from the ink of the squid) was relatively new, having been introduced to Germany at the end of the eighteenth century.[22] Since there was no tradition of sepia painting in Copenhagen, Friedrich must have learned how to use the medium in Dresden, probably from Zingg, who, having recognised its potential, rapidly perfected it for use in landscape compositions such as *The Prebischkegel in Saxon Switzerland* (Fig. 29). Another important exponent of sepia painting in Dresden was Jacobus Crescentius Seydelmann, who had further developed the technique for the purpose of producing monochrome copies after the old masters. In early sepias such as *Cape Arkona at Sunrise* (Cat. 3) Friedrich began by drawing the details of the composition in pencil (often with the aid of a rule and a pair of compasses) before proceeding to lay in the washes. Varying strengths of colour were achieved by judiciously adjusting the proportions of pigment and water and also by the occasional admixture of gum arabic to thicken the medium. The washes thus obtained were then usually applied in a single layer, beneath which the original drawing showed through. In his later sepias and for smaller compositions like the Oxford *Landscape with an Obelisk* (Cat. 8) Friedrich adopted a modified form of Seydelmann's method, which involved the superimposition of several layers of transparent sepia wash, in a manner not dissimilar to glazing, and the subsequent addition of detail painted with small hair brushes.

The sepias bought by Runge in 1803 have still to be positively identified but they were probably painted as pendants, since we know from his description of them that 'the first [was conceived] as morning, the second as evening'.[23] This information is significant, for at about the same time Friedrich painted a cycle of four sepia compositions (believed to have been destroyed in the Second World War) in which parallels were deliberately drawn between the times of the day, the seasons of the year, and the ages of man.[24] In the first of these, naked children gambolled in the early morning light of a spring landscape. In the second, two of the children had become young lovers, seen embracing in a bower sheltering them from the heat of the midday summer sun. In the last, a bearded old man was shown grieving beside an open grave near the ruins of a Gothic church silhouetted against the moonlit winter sky. The third, representing *Autumn*, was unique in containing no figures to connect the sequence of the ages of man. Seen together, these sepias constitute one of the most important clues to our understanding of Friedrich's art, for they affirm through association his fundamentally optimistic philosophy. Just as we know that night is followed by day, and winter just as assuredly by spring, the logic inherent in the cycle implies the inevitability of life after death. The woman lying in her grave in *Winter* will live again just as certainly as the withered tree in the cemetery will soon bring forth new buds. A leitmotif in the *Seasons* cycle is the presence of water, which Friedrich evidently introduced, like Goethe in his poem *Gesang der Geister über den Wassern*, as a metaphor for the passage of time on the one hand and natural renewal on the other. It bubbles from the earth in *Spring*, develops into a broad river in *Summer*, and finally merges with the sea at the end of its course in *Winter*. Our knowledge that it will evaporate and

fall again as rain dispells the apparent pessimism of *Winter* as forcibly as the glimmer of sun in the sky or the hint of an imminent thaw.

In 1807 Friedrich painted oil versions of *Summer* (Neue Pinakothek, Munich) and *Winter* (Fig. 28), which were probably partly inspired by pictures in the Dresden gallery: Claude's *Acis and Galatea* and Ruisdael's *Jewish Cemetery*. He had only rarely experimented with oils, and his unfamiliarity with the technique is demonstrated by the fact that in many of his early oil paintings he applied the paint thinly and drily with very small brushes, as though he were still working in sepia, and in such a way that the underdrawing remained visible to the naked eye. This is especially noticeable in pictures such as *Mist* (Cat. 14, ill. p. 38) and *Seashore with Fisherman* (Cat. 13, ill. p. 38) in the Neue Galerie in Vienna.

Among the first paintings that Friedrich produced, the one that aroused the most excitement was unquestionably *The Cross in the Mountains* (Fig. 6), which was probably based on landscape studies made during a visit to northern Bohemia in August and September 1807. The picture is also known as *The Tetschen Altarpiece*, due to the fact that it was bought by Count Franz Anton von Thun-Hohenstein for his private chapel at Tetschen, after the artist had reversed his decision to present it to Gustavus Adolphus IV of Sweden as a token of his admiration of the king's opposition to Napoleon.[25] In December 1808, before it was despatched to Bohemia, the picture was placed on exhibition in Friedrich's Dresden studio. In order to simulate the chapel for which it was destined, one of the windows was covered so that the studio was only partially lit, and a black cloth was spread on the table where the large framed canvas was to stand. These preparations had the desired effect: countless visitors arrived at the studio to see Friedrich's painting, and Marie Helene von Kügelgen, a friend of the artist, wrote to her husband afterwards that 'it struck all who came into the room as though they were entering a temple. Even the biggest loudmouths spoke quietly and earnestly as though they were in a church.'[26]

But, as Friedrich had expected, *The Cross in the Mountains* was not received favourably in all quarters. One of his chief critics was Friedrich Wilhelm Basilius von Ramdohr, a champion of Neo-classical doctrine, who was affronted as much by the theme of the altarpiece as by the formal language in which it was expressed. In a scathing denouncement of the picture published in January 1809 in the *Zeitung für die elegante Welt*, he accused Friedrich of sacrilege for

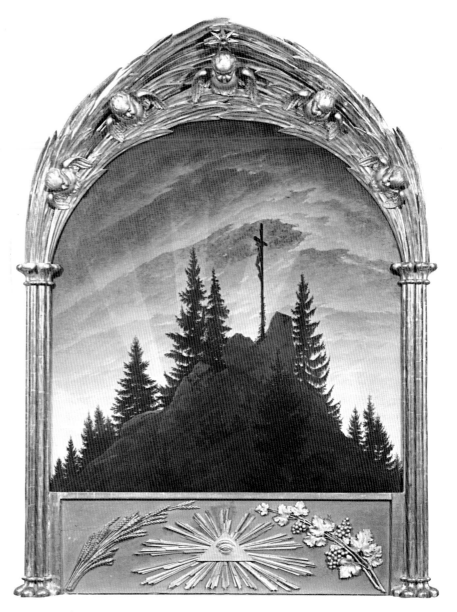

allowing a 'landscape to creep onto the altar' and derogatorily associated his nature symbolism with the 'neoplatonic sophistry' of the Dresden Romantics.[27] During the ensuing debate many of Friedrich's friends, including the painters Ferdinand Hartmann and Gerhard von Kügelgen and the *Phöbus* group of writers in Dresden, came publicly to his support, testifying to his skills as a painter and upholding his right to individual expression. In defence of his ideas, Friedrich took the unusual measure of writing an interpretation of the picture, which was sent first to the writer Friedrich August Schulz, and, after the text had been edited by Christian August Semler, Secretary to the Dresden Library, was published in April 1809 in the *Journal des Luxus und der Moden*.[28] In view of the considerable controversy which *The Cross in the*

Fig. 6 Caspar David Friedrich, *The Cross in the Mountains*, 115 × 110.5 cm, Gemäldegalerie Neue Meister, Dresden

*Mountains* provoked and the fact that Friedrich was motivated to explain the meaning of a specific painting on only one other occasion, it is important to consider carefully what he had to say, for his own interpretation not only provides the means of properly understanding *The Tetschen Altarpiece* itself but gives vital clues to the correct appreciation of the symbols and imagery in his work as a whole. In the *Zeitung für die elegante Welt* Ramdohr had asked:

> Can the indicated scene of nature be painted without sacrificing the most essential merits of painting and particularly of landscape painting? Is it felicitous to use a landscape as an allegory of a specific religious idea or even for the purposes of devotion? Finally, is it compatible with the dignity of art and the truly pious man to invite to worship by such means as Herr F[riedrich] has employed?

Friedrich, leaving the polemical arguments to others, did not address these questions directly, but countered instead with a simple statement of how he meant his picture to be understood. In the short passage that follows he supplied meanings for the rocks, the sun, and the fir trees that enable us to interpret along similar lines paintings such as *Morning Mist in the Mountains*, in Rudolstadt, *Cross and Cathedral in the Mountains*, in Düsseldorf (Cat. 21, ill. p. 39), and the National Gallery's *Winter Landscape* (Cat. 17).

*Interpretation of the Picture*

> Jesus Christ, nailed to the tree, is turned here towards the sinking sun, the image of the eternal life-giving father. With Jesus' teaching an old world died – that time when God the Father moved directly on the earth. The sun sank and the earth was no longer able to grasp the departing light. There shines forth in the gold of the evening light the purest, noblest metal of the Saviour's figure on the cross, which thus reflects on earth in a softened glow. The cross stands erected on a rock, unshakably firm like our faith in Jesus Christ. The fir trees stand around the cross, evergreen, enduring through all ages, like the hopes of man in Him, the Crucified.

At this juncture it is necessary to emphasise that, while the idea of a landscape as an altarpiece was novel, the symbolism which Friedrich employed was not. On the contrary, his symbols and the notions associated with them were firmly rooted in tradition. This is also true of the motifs incorporated in the ornate carved and gilded wooden frame made to Friedrich's specifications by the sculptor Gottlob

Christian Kühn. Here the themes of sacrifice and redemption are reiterated in standard iconographic terms. Palm branches, the conventional symbols of martyrdom, rise from columns on either side to form an arch above the picture. Below, ears of corn and vines, eucharistic allusions to the flesh and blood of Christ, flank the all-seeing eye of God, enclosed within a triangle (to signify the Trinity) from which emanate rays of light like those of the setting sun within the picture. Such traditionalism notwithstanding, when viewed in the context of Friedrich's subsequent career *The Tetschen Altarpiece* now takes on the quality of a manifesto in which the artist openly proclaimed an entirely new direction for landscape painting, where natural elements would be invested with deep religious significance.

From April till May 1809 Friedrich was again in Greifswald; and in July 1810, in the company of Kersting, he undertook a walking tour of the Riesengebirge, which provided him with a stock of new landscape motifs. By now he had virtually abandoned sepia and turned almost exclusively to the production of oil paintings, several of which – like the National Gallery's *Winter Landscape* (Cat. 17) and its companion piece in Schwerin (Fig. 24) – were intended to be seen in series or as pendants, where the interpretation of one picture depends on a knowledge of the other(s). With certain of Friedrich's companion pieces, however, interdependence of this kind is not always so evident, and in the case of *The Monk by the Sea* (Fig. 7) and *Abbey among Oak Trees* (Fig. 8) the precise relationship is very far from clear. Friedrich submitted these two pictures, the largest and most striking he had thus far produced, to the academy exhibition in Berlin in 1810, where they were bought by the future king of Prussia, Friedrich Wilhelm IV, while he was still the young Crown Prince. Royal patronage in this form, coming so soon after the publicity attendant upon the exhibition of *The Tetschen Altarpiece*, had the inevitable consequence of drawing Friedrich's name to the attention of a wider audience, and his success in Berlin in 1810 led to his immediate election as a member of the Berlin Academy.

Contemporary reports of *The Monk by the Sea* at successive phases in its evolution indicate that it underwent a number of important changes between its inception in 1808 and its appearance in October 1810 at the Berlin Academy, where it arrived so late that details of it had to be inserted in an appendix to the catalogue. Semler, who saw the painting in Friedrich's studio in February 1809, described it then

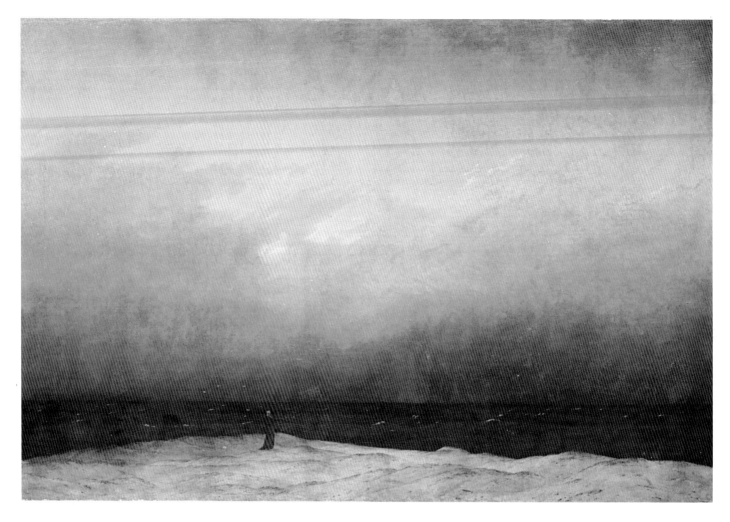

as 'uniformly grey' with a sky 'heavy with mist';[29] and four months later Marie Helene von Kügelgen, in a letter to Friederike Volkmann, wrote of it in similar terms, deploring the absence of either 'sun, moon, or thunderstorm'.[30] By as late as September 1810, however, the sky had been radically transformed to represent night, in which condition it was seen by the Jena publisher Karl Friedrich Frommann, who referred to it in his diary as a view of 'the Baltic . . . with the evening star and the moon in its last quarter'.[31] Finally, between 24 September and 13 October 1810, Friedrich again repainted the sky to produce the effect we are familiar with today. But these were not the only alterations he made. Infra-red photography has revealed the underdrawing for two ships that Friedrich originally intended to depict heeling over in the wind. Their omission and the exclusion from the composition of any kind of framing device resulted in a design so radical that it must have seemed at the time to be a consummation of the

Romantics' dream of representing the infinite in finite terms.

The picture's startling modernity was recognised at once by Heinrich von Kleist, who had moved in 1809 from Dresden to Berlin, where he became a friend of Clemens Brentano and Achim von Arnim. When Arnim and Brentano reviewed *The Monk by the Sea* in 1810 for the *Berliner Abendblätter*, of which he was the editor, Kleist exercised his prerogative by eliminating the tone of irony in their essay and interpolating opinions of his own. The following passage, with which his contribution opened, concludes with a characteristically Kleistian observation:

Nothing could be sadder or more unnerving than this position in the world: the only spark of life in the wide realm of death, the lonely centre of a lonely circle. With its two or three mysterious elements the picture hangs there like the apocalypse, as if it were dreaming Young's *Night Thoughts*, and, since in its uniformity and

Fig. 7 Caspar David Friedrich, *The Monk by the Sea*, 110 × 171.5 cm, Nationalgalerie, Galerie der Romantik, West Berlin

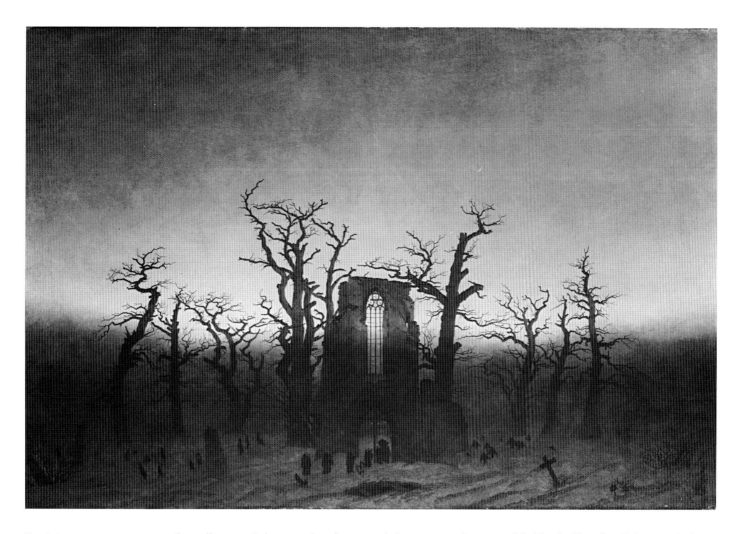

Fig. 8 Caspar David Friedrich, *Abbey among Oak Trees*, 110.4 × 171 cm, Nationalgalerie, Galerie der Romantik, West Berlin

boundlessness it has no other foreground than the frame, when one looks at it, it is as though one's eyelids have been cut away.[32]

In this, as in several of Friedrich's other paintings, the lone protagonist is demonstrably a self portrait, suggesting that an element of autobiography was intended. In *The Monk by the Sea* one suspects an attempt on Friedrich's part to convey some notion of the artist's acute sense of spiritual isolation. In essence it expresses what another north German, the poet Theodor Storm, had in mind when he wrote: 'If we really think about it, every human being lives out his life alone and in terrible isolation; a lost speck in the immeasurable and the unknown.'

Compared with *The Monk by the Sea*, its pendant *Abbey among Oak Trees* (Fig. 8) is pictorially conventional. Its symbolic content broke no new ground, but synthesised two distinct iconographic types in Friedrich's established oeuvre: the kind of winter landscape characterised by *Winter* in the *Seasons* cycle and

that exemplified by the Dresden *Dolmen in the Snow*. Though there are no certain references to the painting before 18 September 1810, when Goethe saw it during his visit to Friedrich's studio, it was probably started shortly after the artist's return from Greifswald in June 1809. Reactions to the picture were mixed. Carus described it as 'perhaps the most heartfelt and poetic work of art in the whole of modern landscape painting',[33] and Theodor Körner was so moved by the picture that it inspired his poem *Friedrichs Totenlandschaft*. The sculptor Johann Gottfried Schadow, on the other hand, took an instant dislike to the picture, criticising the impression it gave of 'a nightwatchman's call echoing in abbey graveyards, where muffled figures creep about in the snow like dolls.'[34]

In June 1811 Friedrich set out on another of his many sketching tours, this time in the direction of the Harz mountains with Gottlob Christian Kühn. On his return journey early in July he called on the painter

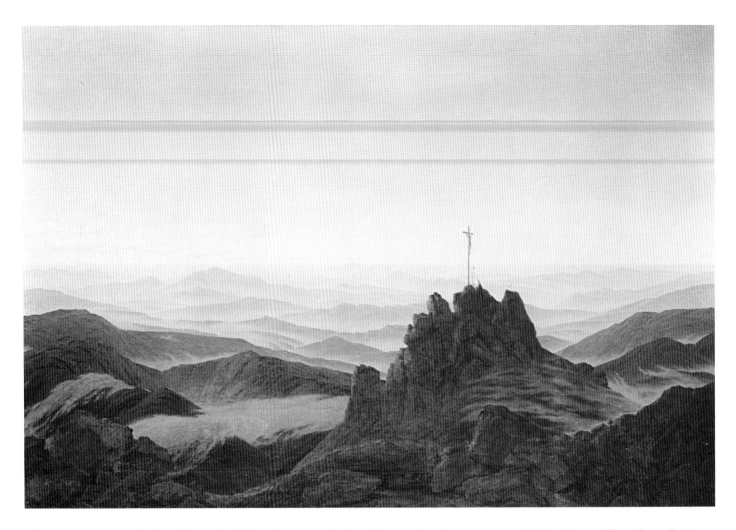

Caroline Bardua in Ballenstädt, and afterwards visited Goethe in Jena. Towards the end of the year the Winter Landscapes now in London and Schwerin (Cat. 17 and Fig. 24), both probably completed before he left Dresden for the Harz, were exhibited together for the first time in Weimar. In the same exhibition was one of Friedrich's largest and most imposing pictures, *Morning in the Riesengebirge* (Fig. 9), which was purchased in 1812 from the Berlin Academy exhibition by Friedrich Wilhelm III. The picture was generally well received and earned especially generous praise from the correspondent of the *Journal des Luxus und der Moden*, who described it as one of the jewels of the show.[35] For the mountain landscape Friedrich made use of sketches he had drawn in the course of his recent tour of the Riesengebirge, but in characteristic fashion he also borrowed from drawings made at other times, in other places. This procedure of amalgamating motifs from a variety of disparate sources, was Friedrich's usual working method, and, excepting the more naturalistic landscapes he produced in the 1820s, was a practice from which he seldom deviated.

As we have seen, from the outset of his career as a landscape painter, Friedrich's primary concern seems to have been to produce pictures of an allegorical kind, and with the passing of the years he formulated an increasingly elaborate system of symbolic images in order to articulate his beliefs in language that would be intelligible to those genuinely seeking to comprehend it. It was in his nature to be reticent about his work, but in the case of the *Cross on the Baltic* (Cat. 22, ill. p. 42) he broke his silence for a second time and made the meaning of his painting deliberately explicit. The picture had probably been undertaken for Therese aus dem Winckel, and on 9 May 1815, while he was still at work on it, Friedrich gave a report of his progress to the painter Luise Seidler, which reveals how consistent was his use of religious imagery:

Fig. 9 Caspar David Friedrich, *Morning in the Riesengebirge*, 108 × 170 cm, Verwaltung der Staatlichen Schlösser und Gärten, Schloß Charlottenburg, West Berlin

The picture destined for your friend is already sketched out but there will be no church in it, nor a tree, nor a plant, nor a blade of grass. Raised up high on the barren, rocky seashore is a cross: to those who see it a consolation; to those who fail to see it, merely a cross.[36]

Having originally developed his symbolic vocabulary for overtly religious purposes, during the French occupation of Dresden and throughout the War of Liberation (1813–15) Friedrich adapted it for use in political allegories directed against the enemy. In July 1813, after the French had entered Dresden, Friedrich retired into voluntary exile in the Elbsandsteingebirge, south of the Saxon capital. Here he executed a small group of paintings, two of which were first shown in March 1814 in the exhibition of patriotic art organised at the Dresden Academy by the Russian governor general, Prince Repnin. Among these was his masterpiece of this period, *The Graves of Fallen Freedom Fighters* (Fig. 10), painted as an outspoken attack against the occupation of German soil by Napoleonic troops. Its forthright political message is emphasised by the presence in the foreground of a serpent with red, white and blue stripes – the symbol of evil in the colours of the tricolour. At the entrance to the cave in the background, based on drawings Friedrich had made during his recent tour of the Harz, stand two French chasseurs amid the tombs of German patriots who had died in the cause of liberty. Close inspection reveals that these chasseurs are keeping watch close to a sarcophagus, an obvious allusion to the soldiers guarding the tomb of Christ. Friedrich's motive was plainly to suggest a secular resurrection foretelling the impending liberation of Germany and the expulsion of the French, in which context the prominence accorded to the grave of

Fig. 10 Caspar David Friedrich, *The Graves of Fallen Freedom Fighters*, 49.5 × 70.5 cm, Kunsthalle, Hamburg

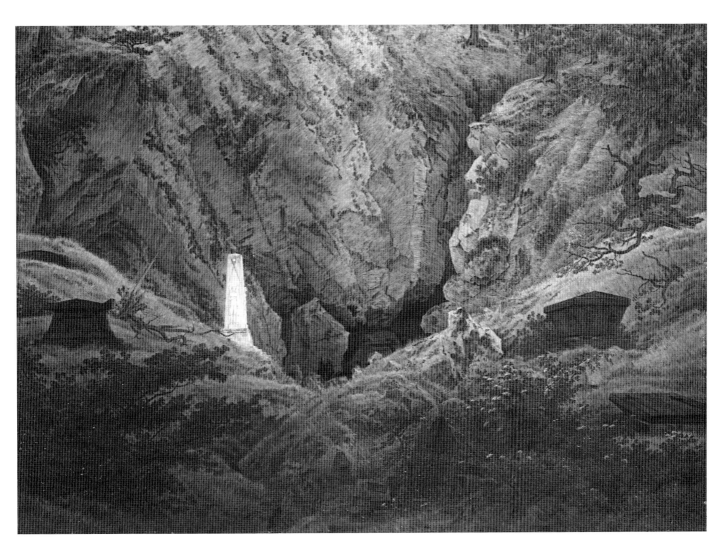

Arminius (the hero of Kleist's recent drama *Die Hermannschlacht*) gains added significance, since it was he who was responsible for defeating the Roman legions in the Teutoburg Forest, ridding the ancient Germans of their hated foreign overlords.

Though he temporarily abandoned patriotic subjects almost immediately the war with France was over, Friedrich remained faithful to his democratic principles, commenting openly on the deteriorating political situation in Germany in pictures such as *Ulrich von Hutten's Tomb* (Fig. 11), in which his commitment to the ideals of nationalism and liberalism found their most cogent and heartfelt expression. Conceived in terms of an allegorical epitaph, *Ulrich von Hutten's Tomb* was probably begun in 1823, on the tenth anniversary of the start of the War of Liberation. This year also marked the tercentenary of the death of the eponymous patriot, a humanist supporter of Luther who had died in exile in Switzerland following an abortive revolt by Imperial knights in 1523. To the chagrin of Friedrich's liberal-minded contemporaries, no monument to Hutten had ever been erected, and the tomb in the picture is the artist's own invention. In a Gothic ruin, inspired by the chancel of the ruined abbey church at Oybin, Friedrich depicted a soldier dressed in the 'medieval' uniform of the Lützow volunteers meditating before Hutten's tomb. On the wall to the right is a headless statue of Faith, and from a dark crack in the tomb itself a butterfly, the ancient symbol of the soul, emerges into the light as if to confirm the survival of Hutten's ideals. The sides of the monument are inscribed with the names of men who had played a vital part in the War of Liberation: Jahn, Arndt and Stein, outspoken critics of the restoration; Görres, who was forced into exile by the Prussian government and, like Hutten, died in Switzerland; and Scharnhorst, who had fallen at the Battle of Leipzig. By linking their names with the memory of the most revered freedom fighter of the Reformation, Friedrich incorporated in his tribute to Hutten an unambiguous indictment of the repressive measures that had prevailed in Germany since 1815. Paintings such as *The Wreck of the Hope* and *Arctic Shipwreck* (Fig. 20) may have been conceived with broadly similar intentions. For a decade Friedrich was also busy projecting designs for war memorials, one of which he had planned as early as 1814 as a tribute to Scharnhorst, convinced 'that no such monuments [would] be erected ... so long as we remain the minions of princes.'[37]

In August 1815 Friedrich again went back to his Baltic homeland, where he made detailed studies of

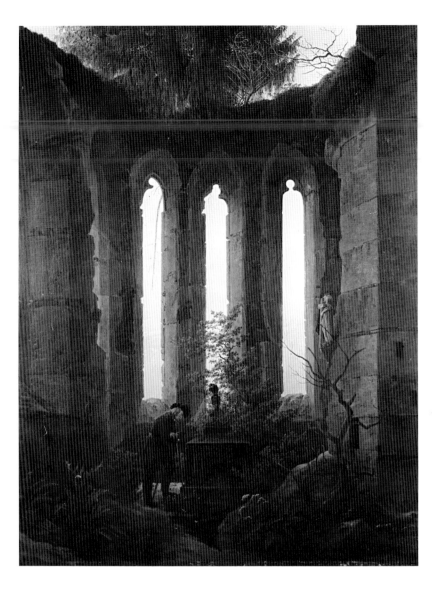

shipping in preparation for a series of marine subjects which preoccupied him for the next few years. The most important picture executed on his return to Dresden was the *View of a Harbour*, now in Schloss Charlottenhof, Potsdam-Sanssouci, which incorporates motifs from the harbour at Greifswald and sketches of ships and smaller craft at sea recorded during his recent visit. On its completion in 1816 the painting was shown first in Dresden and later at the Berlin Academy exhibition, where it was bought by Friedrich Wilhelm III as a birthday present for the Crown Prince. Whether or not Friedrich intended it to represent the harbour at Greifswald is uncertain. An inventory of the pictures at Schloss Charlottenhof compiled in 1840 describes it as the harbour at Stralsund, but Friedrich probably had no specific

Fig. 11 Caspar David Friedrich, *Ulrich von Hutten's Tomb*, 93 × 73 cm, Staatliche Kunstsammlungen, Weimar

locality in mind. From what we know of his thought processes at this time and of the iconographic role which the ship played in his art, it is much more likely that he intended the peaceful evening scene, with the ships riding lightly at anchor, as a metaphor for the spiritual tranquillity with which the Christian believer can contemplate the approach of death.

Among Friedrich's marine paintings of this period one series is worthy of special attention for the light that it sheds on this and other works whose meanings might otherwise have remained enigmatic. The cycle in question deals again with *The Times of Day* but presents them in the guise of seapieces. The little painting of *Morning* (in Hanover) is the first in the sequence and depicts a small sailing boat setting out to sea in a fresh breeze shortly after daybreak. *Noon* (now lost) represented shipping on the high seas; *Evening* (Bührle Collection, Zurich) shows the return of a boat to harbour; and *Night* (private collection, Zurich) a boat moving by moonlight towards some unseen destination. Drawing on our knowledge of the

earlier *Seasons* cycle, it seems likely that, as in some seventeenth-century Dutch marine paintings, the boat is intended to designate the 'ship of life', an idea that found more mature expression in Friedrich's *Moonrise over the Sea* (Fig. 12) and the later *Stages of Life* (Fig. 13).

*Moonrise over the Sea*, completed by 1 November 1822, treats a recurrent theme in Friedrich's work, the return of ships to harbour as the day draws to its close. The people gazing wistfully at the vessels outlined ethereally against the moonlit sky convey through their bodily attitudes their common involvement in the natural spectacle before them. As in so many of Friedrich's pictures, the figures have their backs towards us, and because we participate in the same visual experience we identify closely with them. In his *Nine Letters on Landscape Painting*, published in 1831, Carus observed how effective such a device could be, remarking that 'a lonely figure lost in contemplation of the silent scene will prompt the spectator of the picture to think himself in his

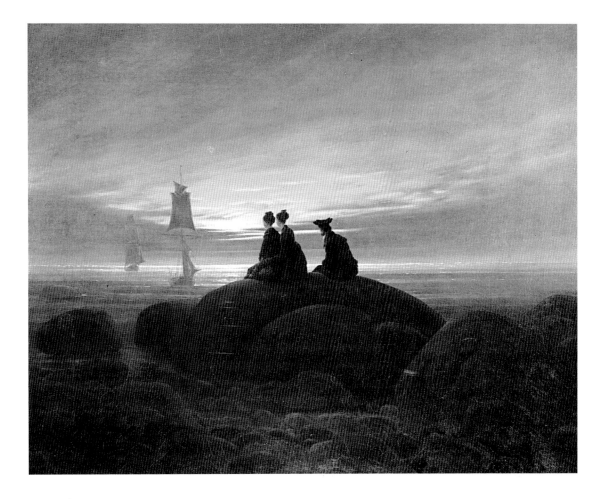

Fig. 12 Caspar David Friedrich, *Moonrise over the Sea*, 55 × 71 cm, Nationalgalerie, Galerie der Romantik, West Berlin

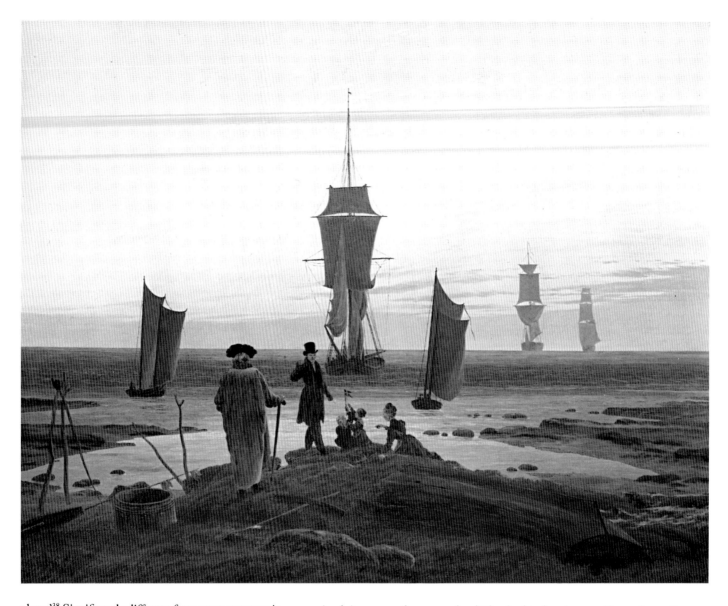

place.'[38] Significantly different from mere repoussoir figures, their united response here lends emphasis to the prevailing mood of melancholy, which Friedrich, ever sensitive to the emotional power of colour, achieved by judicious use of one of his favourite colours, violet. That the practical application of his colour theory was appreciated by his contemporaries is attested by Ludwig Richter, who maintained that 'green is fresh and lively, red joyful, . . . violet melancholy (as with Friedrich).'[39]

*The Stages of Life* takes the theme of the 'ship of life' an important step forward by concentrating in one picture the narrative and allegorical ideas formerly divided among four in the marine cycle *The Times of Day*. Though *The Stages of Life* is a modern title,

coined in 1904, there can be little doubt that it accurately reflects the artist's intentions. Friedrich chose members of his own family to represent the different age groups. The old man in the grey fur coat with his back towards us is Friedrich himself. The children are his son Gustav Adolf, holding the Swedish flag, and his daughter Agnes Adelheid. Though his identity is more problematic, the man in the top hat is most probably Friedrich's nephew Johann Heinrich (for whom the picture may have been painted), and the young woman either Friedrich's wife or their daughter Emma.

Friedrich had married on 21 January 1818, at a time when he was still recovering from the artistic crisis to which he had referred two years before in a

Fig. 13 Caspar David Friedrich, *The Stages of Life*, 72.5 × 74 cm, Museum der bildenden Künste, Leipzig

letter to the friend of his student days, Johan Ludwig Gebhard Lund.[40] Outwardly, however, his career seemed to be progressing well. According to Carus (whom he met in 1817), he was experiencing no difficulty selling his pictures; at exhibition his work was enthusiastically reviewed; and on 4 December 1816, following the death of Zingg, he had been elected a member of the Dresden Academy with a generous annual stipend of 150 thaler.

In addition to seapieces, which accounted for most of Friedrich's output in the first few years following the war, around 1817 he began work on a larger variant of *Abbey among Oak Trees* entitled *Monastery Graveyard in the Snow* (destroyed in 1945), and, while this was still in progress, executed quite the most delightful picture of this period, *Chalk Cliffs on Rügen* (Fig. 14). Probably begun immediately after his

Fig. 14 Caspar David Friedrich, *Chalk Cliffs on Rügen*, 90.5 × 71 cm, Museum Stiftung Oskar Reinhart, Winterthur

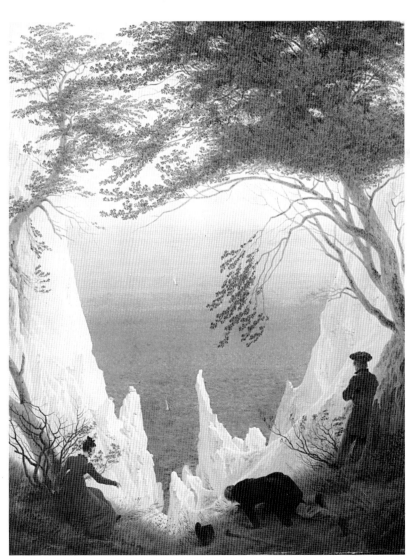

return to Dresden following his Baltic honeymoon in the summer of 1818, Friedrich's joyous souvenir of the island, depicting sun-drenched pinnacles of chalk silhouetted against the dappled azure sea, imprints itself indelibly on the memory as a work of vivacity unrivalled in his oeuvre. The chalk cliffs are those at Stubbenkammer, a noted beauty spot of which Friedrich was especially fond. He had already recorded the fantastic configurations of the chalk face on consecutive pages of his sketchbook on 1 August 1815, and he presumably returned to these for the underdrawing of his painting. Friedrich and his bride had been accompanied on their trip to Rügen by his sister-in-law and his brother Christian. In the picture, Friedrich is in the middle, leaning over the edge, to the left is his wife Caroline, and to the right his brother. Christian's mood of silent contemplation is in marked contrast to the ungainly sprawling movement of the artist himself, whose motive in peering precariously over the clifftop remains unexplained. The most extraordinary aspect of the picture, however, is Friedrich's undisguised delight in manipulating paint. Notably in his treatment of the sea, there are passages where, without any debasement of the word, Impressionistic is the only term one can use to describe the effect.

Shortly before painting this picture, Friedrich had commenced what may have been his first *Gedächtnisbild* (a picture in memory of someone who had recently died) – the *Memorial Picture to Johann Emanuel Bremer* (Fig. 15). The man in whose memory this was painted was a Berlin doctor of Friedrich's acquaintance, remembered with special affection for his work among the poor and for the introduction to the city of inoculation against smallpox. He died, aged sixty, on 6 November 1816, and Friedrich's picture was presumably started not long afterwards. An interesting feature of the painting is the working of Bremer's surname into the metalwork of the garden gate, a conceit that may have been prompted by the cast-iron gates at Schloss Paretz, erected in 1811 by Friedrich Wilhelm III after the death of Queen Luise, in which her own personal monogram was set in similar fashion.[41] The elegiac tone of this picture is unmistakable and Friedrich's unerring colour sense was used to particularly poignant effect. In the context of the *Gedächtnisbild*, the vines are undoubtedly meant as eucharistic symbols, and the spires of Greifswald's skyline appear beyond the water like some celestial vision. Death, here represented in the form of an iron gate, is thus clearly to be interpreted not as an end but as a beginning – *mors janua vitae*.

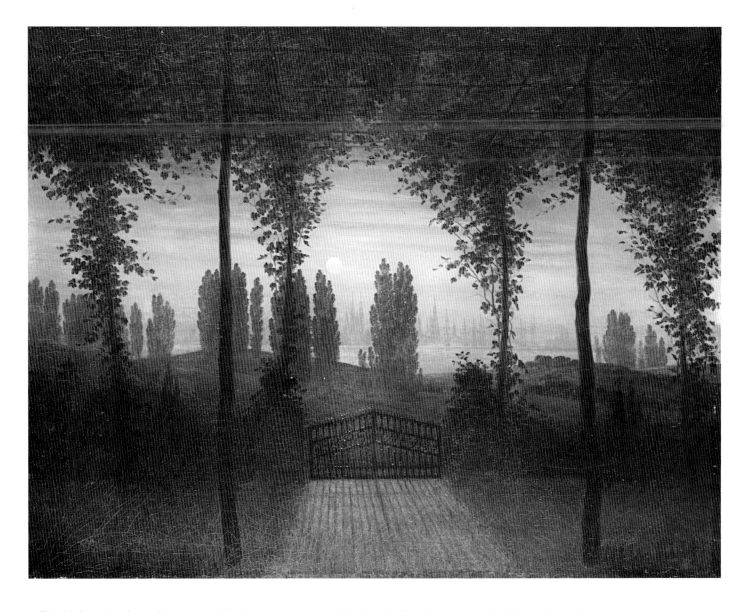

Friedrich painted another memorial picture in 1822 (private collection, Berlin) honouring his friend and fellow painter Gerhard von Kügelgen, who had been murdered by a student on 27 March 1820. Presented to his widow before her departure from Dresden, it depicts the Catholic cemetery in the Friedrichstadt district of Dresden where Kügelgen was interred, with an open grave in the foreground as a vivid *memento mori* and a view through the churchyard gate towards the rising sun. A similar picture is *Cemetery at Dusk* (Fig. 16), which Carl August Böttiger reported seeing in progress during a visit to Friedrich's studio in 1825.[42] Due perhaps to the artist's serious illness of 1824–6, the work was never completed and it remained in his possession until his death. That *Cemetery at Dusk* is another of Friedrich's memorial pictures may be deduced both from Böttiger's description of the painting and from remarks made by the Russian poet Vasily Andreyevich Zhukovsky in a letter of October 1826 to the Grand Duchess Alexandra Feodorovna:

> From time to time I see the painter Friedrich here. He has started a large landscape, which will be magnificent if the execution matches its conception. A large iron gate, which leads into a cemetery, stands open; by the gate, leaning on one of its posts and partly covered by its shadow, a man and a woman can be seen. They are a husband and wife who have just buried their child and in the night are looking at its

Fig. 15 Caspar David Friedrich, *Memorial Picture to Johann Emanuel Bremer*, 43.5 × 57 cm, Verwaltung der Staatlichen Schlösser und Gärten, Schloß Charlottenburg, West Berlin

24

grave, which is visible inside the cemetery. It is just a little grass mound, beside which one can see a spade. Streaks of mist lie over the cemetery, hiding the tree trunks from sight so that they seem to be detached from the ground. One can make out other graves through the misty veil, and, above all, natural monuments[!]; an upright stone has the appearance of a grey ghost.[43]

The massive stone gateway, which Friedrich doubtless used as a solemn symbol of the barrier between this world and the next, resembles the entrance to the old Trinitatis cemetery in Dresden. What Zhukovsky interpreted as a night scene was probably meant as early morning, for the mist appears to be rising in the warmth of the emerging sun.

Fig. 16 Caspar David Friedrich, *Cemetery at Dusk*, 143 × 110 cm, Gemäldegalerie Neue Meister, Dresden

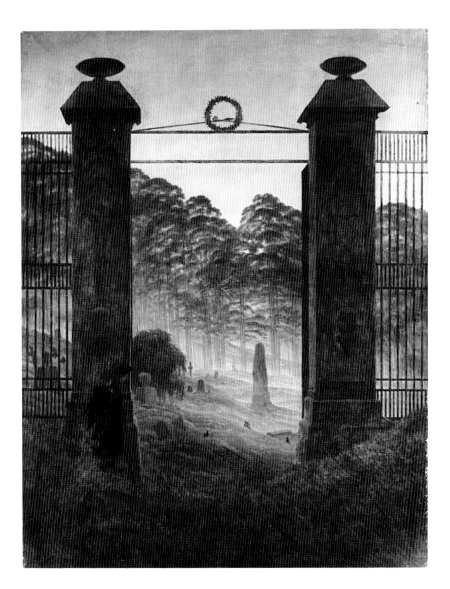

A third memorial picture for which Friedrich chose a cemetery as his subject is *Churchyard in the Snow* (Museum der bildenden Künste, Leipzig), which was painted for the Leipzig collector Baron Maximilian Speck von Sternburg, probably in 1826. As a memorial picture it is somewhat unusual for it seems to have been commissioned by the baron as a future monument to himself. According to Friedrich Pecht,[44] the baron made elaborate arrangements for his own funeral and selected the site where he wished to be buried, so the open grave in the foreground is almost certainly to be construed as his own. From the compositional point of view, *Churchyard in the Snow* is typical of Friedrich's tendency in the mid 1820s to reduce the angle of vision and focus closely on his subject. Unlike most of his graveyard scenes, but in common with *Kügelgen's Grave*, the present picture is unusual in depicting a view from within the cemetery looking out through the churchyard gate. In other respects, however, it is consistent with most of Friedrich's works of this kind, containing – in addition to graves and crosses – other traditional *vanitas* symbols such as dead flowers and leafless trees. But lest such images be interpreted as evidence of Friedrich's pessimism, it is vital to remember that 'the great white blanket of snow' covering the ground represented for him 'the essence of the utmost purity, beneath which nature prepares herself for a new life.'[45]

Speck von Sternburg owned three other works by the artist: a *Seapiece by Moonlight*, now in Leipzig; a watercolour of a *Landscape in the Riesengebirge*, now in Cologne; and *Boats in the Harbour at Evening*, now in Dresden, of which he took possession sometime before Easter 1828. Like the earlier *Churchyard in the Snow*, the last of these seems to have been commissioned with the intention of preserving the baron's memory, for his name is inscribed on the stern of the rowing boat in the foreground of the picture. The baron's 'ship of life' lying peacefully at its mooring in the harbour serves as a personal *memento mori* in a picture of universal significance, where the coming together of the fleet at eventide suggests the communion of Christian souls and the setting sun the imminence of death.

The increasing importance which Friedrich paid to colour in the 1820s and his obvious pleasure in the handling of paint, which previously had often been rather thin and dry, may be attributable to his close friendship with the Norwegian painter Johan Christian Clausen Dahl, who arrived in Dresden in 1818 and with whom from 1823 Friedrich shared his

Fig. 17 Caspar David Friedrich, *Landscape with Windmills*, 27.7 × 41.1 cm, Verwaltung der Staatlichen Schlösser und Gärten, Schloß Charlottenburg, West Berlin

Fig. 18 Caspar David Friedrich, *Landscape with Windmills*, pencil, 23.7 × 37 cm, National Gallery, Oslo

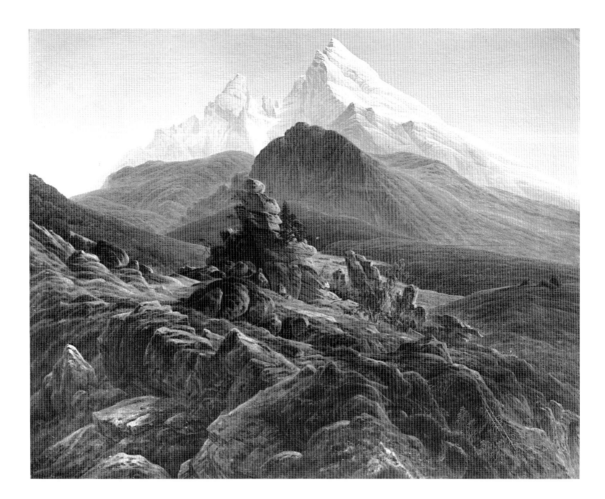

Fig. 19 Caspar David Friedrich, *The Watzmann*, 133 × 170 cm, Nationalgalerie, Galerie der Romantik, West Berlin

house.[46] On several occasions they exhibited together, and an examination of their work reveals how mutually beneficial their close collaboration proved to be. Under Dahl's influence, Friedrich began to execute pictures such as *The Times of Day*, in Hanover, or *Clouds in the Riesengebirge*, in Hamburg, in which he seems to have been concerned solely with capturing the changing moods of nature or fleeting effects of light. Two oil studies of skies – one in Vienna, the other in Mannheim – testify to his desire at this time for greater naturalism in his paintings, some of which, like *Flat Country Landscape*, in West Berlin, and *Landscape with Windmills* (Fig. 17), are evidently records of views the artist had seen. This is demonstrably so in the case of *Landscape with Windmills*, which is based directly on a study from nature, in Oslo, from one of Friedrich's dismembered sketchbooks (Fig. 18). The almost verbatim correspondence between the painting and the drawing, with only minimal alterations or additions to the composition, provides telling proof of Friedrich's growing awareness of the beauty of simple landscape motifs

unencumbered with symbolism. In 1823 the pictures were exhibited as pendants at the Dresden Academy, where they had a mixed reception. Some correspondents considered them 'prosaic' and 'rather cold in tone', but the critic of *Der Gesellschafter* admired them for their 'simplicity and graceful charm'.[47]

In the 1820s Friedrich returned to the depiction of mountain landscapes, for many of which he relied on drawings made a decade or more earlier during his tours of the Riesengebirge and the Harz. On two occasions he painted Alpine views which he had never seen, relying instead on studies by Carus and his pupil August Heinrich. *The Watzmann* (Fig. 19), entirely devoid of human habitation and activity, is arguably Friedrich's most hieratic mountain subject, and, like his *Temple of Juno at Agrigentum*, in Dortmund, may have been intended to challenge the Italianate manner of landscape painting currently being practised in Rome in the circle of Joseph Anton Koch, and exemplified by Ludwig Richter's version of the same subject, in the Neue Pinakothek, Munich. The title of Friedrich's painting is somewhat misleading since, in

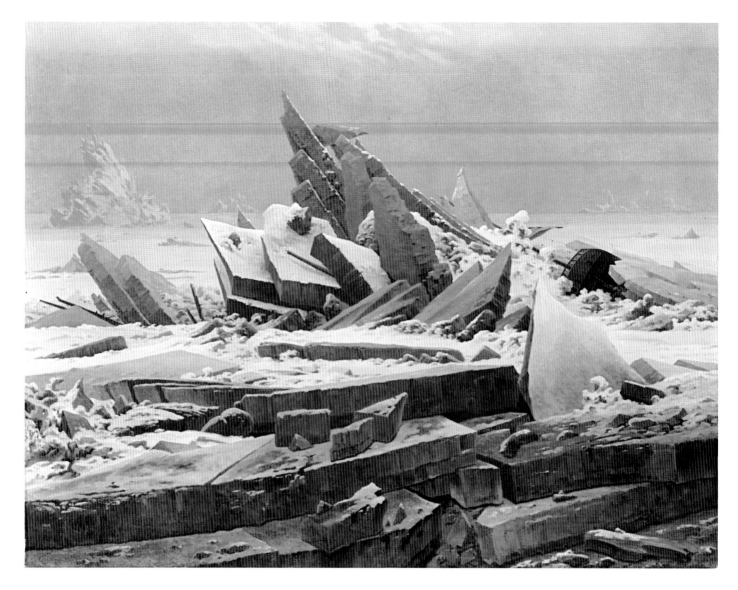

addition to the Watzmann itself, the artist included recognisable motifs from other mountain ranges: in the foreground the unmistakable rocks of the Elbsandsteingebirge, and in the middle distance the massive crag in the Harz mountains known as the Erdbeerkopf. For this and the snow-covered peak of the Watzmann itself Friedrich used Heinrich's watercolour sketch of 1821, in Oslo. Heinrich, who was Friedrich's favourite and most talented pupil, died in 1822, when he was only twenty-eight. This was three years before *The Watzmann* was first exhibited in Dresden, and Friedrich, who had inherited the watercolour, may well have copied it as a kind of tribute, perhaps conceiving his painting as a memorial picture to his young disciple. Birch trees like those in the foreground were often employed by

Friedrich for their association with the Resurrection, and his contemporaries, versed in the iconography of German Romanticism, would have recognised in the image of the inaccessible, pure white mountain peak, perpetually covered in snow and ice, a conscious allusion to the Godhead. Interpreted in this way, the inclusion of the other mountain ranges assumes greater significance, for Friedrich thereby established a meaningful contrast between the more walkable terrain of the Elbsandsteingebirge (a metaphor for our earthly existence) and the remoter icecapped summit, attainable only after the deep valley that lies hidden beyond the middle ground has been traversed.

A picture painted in the same spirit as *The Watzmann*, but infinitely more compelling in its imagery, is the Hamburg *Arctic Shipwreck* (Fig. 20),

Fig. 20 Caspar David Friedrich, *Arctic Shipwreck*, 96.7 × 126.9 cm, Kunsthalle, Hamburg

one of the artist's undisputed masterpieces. A secure *terminus post quem* for the work is provided by three small oil studies of floes (Kunsthalle, Hamburg) that Friedrich painted in the winter of 1820–1 during the breaking up of ice on the Elbe, details from which he incorporated in his picture. Begun at the latest in 1823, the painting was ready in time for the Prague Academy exhibition early the following year. It was exhibited again in August at the Dresden Academy, and in 1826 at the first exhibition organised by the Hamburg Art Union. As the result of confusion with another picture of a similar subject painted in 1822 for Johann Gottlob von Quandt, *Arctic Shipwreck* long masqueraded under the erroneous title *The Wreck of the Hope*. According to Böttiger, who visited Friedrich's studio in 1825, the ship in the present picture represents *The Griper*, one of two vessels under the command of William Edward Parry that took part during 1819–20 and again in 1824 in the search for a north-west passage.[48] Parry's account of his first polar expedition, *Journal of the Voyage for the Discovery of a North-West Passage from the Atlantic to the Pacific*, first published in 1821, was translated into German the following year. Even more interestingly, an article in the *Literarisches Conversationsblatt* of 25 January 1821, reporting Parry's exploits, made specific reference to an incident during the voyage when packs of ice threatened to destroy *The Griper*. It may have been from these narratives that Friedrich derived the initial inspiration for his work, and it is possible that he also saw Johann Carl Enslen's panorama of the *North Pole Expedition* when it was exhibited in Dresden in 1822. By this time the depiction of arctic landscapes was no longer a novelty. What distinguishes Friedrich's picture from other treatments of the subject is the monumentality of its conception, which transcends the purely incidental and invests the painting with what David d'Angers described as '[une] grande et terrible poésie'. Friedrich, he continued, 'a parfaitement compris que l'on pouvait faire servir le paysage à peindre les grandes crises de la nature.'[49]

On 17 January 1824 Friedrich was engaged as Associate Professor at the Dresden Academy with a stipend of 200 thaler, but, to his bitter disappointment, on the death of Johann Christian Klengel on 19 December he was not invited to assume the post of Professor of Landscape Painting, which remained vacant until the appointment of Ludwig Richter ten years later. In 1825 he was laid low by an illness that grew gradually more serious, until in May 1826 he was obliged to leave Dresden and recuperate on the island of Rügen. As a consequence of his illness

Friedrich's production of oil paintings diminished during this period, but around 1824–5 he completed a series of thirty-seven watercolour views of Rügen that, to judge from the few which survive, were among the most lyrical works he ever produced in this medium. He also returned at this time to painting in sepia, resuming the theme of *The Ages of Man*, which he expanded in 1826 and again in 1834 into cycles of seven compositions treating the progress of the spirit through life. For a while he continued painting in watercolours, and during a short visit to Teplitz in Bohemia in May 1828 he executed a group of five views from nature, which, contrary to his customary practice, he drew first in ink before applying a subtle watercolour wash. The *Landscape near Teplitz*, in Kiel, depicting bright green cornfields in the dewy light of morning, is typical of the economy and spontaneity that are the hallmarks of his later watercolour compositions.

Having briefly concentrated at the end of the decade on pictures depicting a single simple motif such as a tree, a doorway, or a cluster of bushes, by the beginning of the 1830s Friedrich had returned to more conventional compositions, the majority of which were either seapieces, or landscapes in the Riesengebirge or the mountains of northern Bohemia. Many of the seapieces were treated as night scenes, and one of the most important of these is *Evening on the Baltic* (Fig. 21), which was bought in 1831 by the Saxon Art Union from the Dresden Academy exhibition. The coastline closely resembles the Greifswalder Bodden, where the River Ryck flows into the Baltic. As in many of Friedrich's marine subjects, the composition derives ultimately from the Dutch seventeenth-century seapiece, but pictures by Claude-Joseph Vernet may have been of more immediate inspiration. Friedrich undoubtedly knew Vernet's work through the medium of engravings, but there is evidence here to suggest that he also had first-hand knowledge of his paintings. The poetic contrast between the cool natural light of the moon and the warm glow of the fire recalls particularly the sort of effect that Vernet exploited in pictures such as *Harbour by Moonlight*, in the Palais du Senat, Paris.

Of Friedrich's many mountain landscapes from this period one of the most magisterial, despite its unfinished state, is the Oslo *Landscape in the Riesengebirge* (Fig. 22). This was one of several canvases left unfinished when Friedrich died in 1840 and bought by Dahl from the sale of the artist's studio effects held in Dresden in December 1843. Unanimously re-

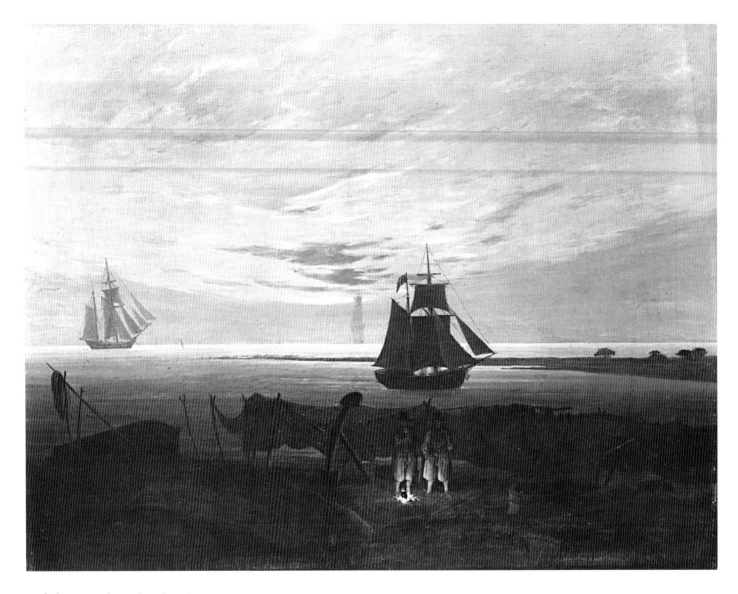

garded as a work produced in the early 1830s, the broad, rather shaky brushstrokes visible in the foreground possibly indicate that Friedrich returned to the picture following his stroke in 1835. Elsewhere in the painting there is much greater freedom of handling than normal, but while this possibly reveals an attempt at greater naturalism it is more probably explained by the fact that the picture was abandoned in its early stages. For the mountain background Friedrich referred to a drawing of the Schmiedeberger Kamm made at Warmbrunn on 13 July 1810 during his walking tour of the Riesengebirge. However, though his depiction of the distant mountain ridge and the surrounding wooded foothills shows strict regard for topographical accuracy, it seems not to have been the artist's aim to produce a faithful record of a particular scene. He replaced the field of ripening corn that is a prominent feature in the foreground of his drawing with an undulating rocky landscape reminiscent of the countryside south of Dresden and bearing little resemblance to the local terrain.

By far the most beautiful work of the 1830s, if not of Friedrich's entire career, is *The Large Enclosure near Dresden* (Fig. 23). Attempts have been made to identify it with one or other of two Landscapes by Moonlight which Friedrich sent to the Dresden Academy exhibition in August 1832 (nos 534 and 535), but the evidence is unconvincing. However, for reasons of style alone, it must have been painted around this time, and it was certainly finished before the end of 1832, since it was included in the Saxon Art Union's lottery in December the same year. The

Fig. 21 Caspar David Friedrich, *Evening on the Baltic*, 54 × 71.5 cm, Gemäldegalerie Neue Meister, Dresden

'Large Enclosure', the Ostra-Gehege, was an unspoiled tract of meadowland with natural avenues of linden trees on the southern bank of the Elbe, north-west of Dresden. An area of outstanding beauty, it inspired Friedrich to create what is widely acknowledged as one of the great masterpieces of European landscape painting. Redolent of the tranquillity of the countryside at dusk, this ravishing

him very weak, and from then until his death, having lost the strength to paint in oils, the only works that he produced were sepias and watercolours on old and familiar themes. As if in nostalgic recollection, he now reserved watercolour almost exclusively for the depiction of his favourite mountain landscapes, but his late sepias struck a decidedly more lugubrious note. In these, dolmens, ruined buildings and

Fig. 22 Caspar David Friedrich, *Landscape in the Riesengebirge*, 72.5 × 103 cm, National Gallery, Oslo

picture, with its subtle nuances of colour and soft tonal transitions, consummately portrays the poetic effects of reflected light. Although the most simple in its formal language of all Friedrich's great landscapes, paradoxically *The Large Enclosure near Dresden* is also his most eloquent.

The stroke Friedrich suffered on 26 June 1835 effectively brought his career to an end. On his return to Dresden at the end of September after six weeks' convalescence at Teplitz, made possible by the sale of pictures to Tsar Nicholas I, he briefly resumed work on some of his unfinished canvases and even summoned the energy to embark on a few new pictures, though these were largely repetitions of earlier compositions. When Wilhelm von Kügelgen visited Friedrich in March 1836, however, he found

churchyard scenes predominate, indicative perhaps of his morbid preoccupation with the imminence of death. Friedrich ceased working altogether in 1839 and he died on 7 May the following year. Three days later his mortal remains were borne to the Trinitatis cemetery in Dresden and interred. For more than a decade the tide of taste had been turning against him in favour of the more naturalistic landscapes of Düsseldorf artists like Carl Friedrich Lessing. Appreciative reviews of his work had also become less common and, despite his inclusion in 1837 in Nagler's *Dictionary of Artists*, by the time of his death Friedrich was already neglected. Even during his lifetime he had frequently been misunderstood and his art was too intensely personal to be conducive to the establishment of any kind of school. Among the

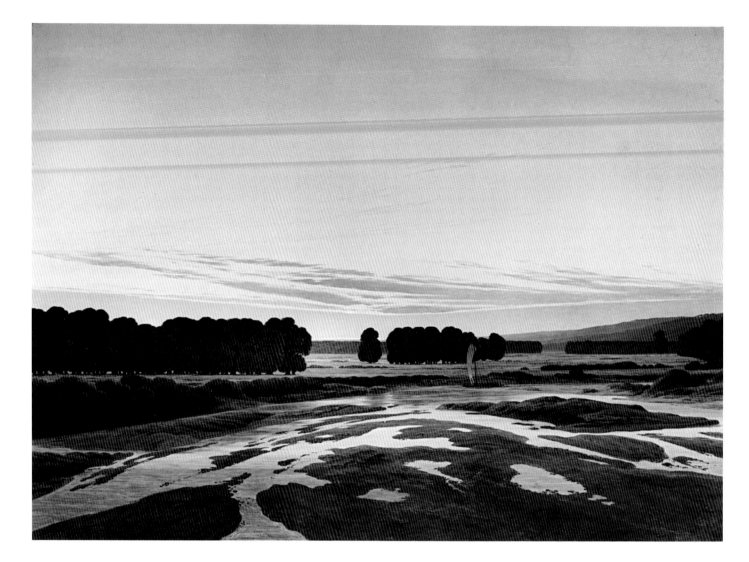

artists most deeply influenced by him were Carus, Ernst Ferdinand Oehme and Carl Julius von Leypold. To varying extents all three modelled their style on his and attempted to assimilate his symbolic vocabulary. Occasionally Carus produced works of such quality (and, one suspects, with such feeling) that they might just be mistaken for those of his teacher. Where Oehme and Leypold are concerned, however, even when they based their own compositions directly on Friedrich's paintings and borrowed from his repertory of symbols, their works were not nearly as compelling. It was in the nature of Friedrich's genius to be inimitable.

NOTES

I am indebted to the British Academy for a generous research grant which enabled me to study in Copenhagen and Munich in preparation for the production of this catalogue and my forthcoming book on Friedrich.

The abbreviation BS/J refers to Helmut Börsch-Supan and Karl Wilhelm Jähnig, *Caspar David Friedrich: Gemälde, Druckgraphik und bildmäßige Zeichnungen*, Munich, 1973.

1. In his monograph *Den nordiske Naturfølesle og Johan Christian Dahl* (Christiania, 1894), Aubert devoted several pages to Friedrich which were published in German translation as 'Der Landschaftsmaler Friedrich' in *Kunstchronik*, new series VII, 1895–6, pp. 283–93.
2. Tate Gallery, London, 'Caspar David Friedrich 1774–1840. Romantic Landscape Painting in Dresden', 1972; Kunsthalle Hamburg, 'Caspar David Friedrich 1774–1840', 1974; Albertinum, Dresden, 'Caspar David Friedrich und sein Kreis', 1974.
3. Friedrich voiced his criticisms of contemporary painting in a series of desultory remarks apparently written down around 1830. A selection of twenty-two of these was

Fig. 23 Caspar David Friedrich, *The Large Enclosure near Dresden*, 73.5 × 102.5 cm, Gemäldegalerie Neue Meister, Dresden

published by Carus in *Friedrich der Landschaftsmaler*, Dresden, 1841, pp. 11–20. The complete text was first published under the heading 'Äußerung bei Betrachtung einer Sammlung von größtenteils noch lebenden und unlängst verstorbenen Künstlern' in Kurt Karl Eberlein, *Caspar David Friedrich. Bekenntnisse*, Leipzig, 1924, and appeared again more recently in Sigrid Hinz, *Caspar David Friedrich in Briefen und Bekenntnissen*, Berlin and Munich, 1968, pp. 84–134.

4. Quoted in Herbert von Einem, *Caspar David Friedrich*, Berlin, 1938, p. 122.

5. Hinz, op. cit., p. 86.

6. Ibid., p. 92. One is reminded by this of Hegel's dictum 'Der wahre Inhalt des Romantischen ist die absolute Innerlichkeit.'

7. Ibid., p. 128.

8. Ibid., p. 92.

9. Carl Gustav Carus, *Lebenserinnerungen und Denkwürdigkeiten*, I, Leipzig, 1865, p. 207.

10. Ibid., II, p. 388.

11. Carl Gustav Carus, 'Friedrich der Landschaftsmaler', *Kunstblatt*, 1840, p. 363.

12. See Werner Sumowski, *Caspar David Friedrich-Studien*, Wiesbaden, 1970, p. 12.

13. Compare, for example, Friedrich's remark to Peter Cornelius in April 1820: 'The divine is everywhere, even in a grain of sand.' Quoted in Hinz, op. cit., p. 220.

14. *Reglement for Maler-, Billedhugger- og Bygnings-Academiet paa Charlottenborg Slot i Kiøbenhavn*. According to this regulation, which came into effect on 21 June 1771, remission of fees was granted automatically only to Danish nationals, but it seems to have been fairly common practice to extend the privilege to others.

15. See F. Meldahl and P. Johansen, *Det kongelige Akademi for de skjønne Kunster 1700–1904*, Copenhagen, 1904, p. 63.

16. In the life class at the Copenhagen Academy all professors were required to teach for a month at a time in rotation.

17. See BS/J, p. 16.

18. Johann Georg Sulzer, *Allgemeine Theorie der schönen Künste*, 2nd edn, III, Leipzig, 1792, p. 150.

19. Philipp Otto Runge, *Hinterlassene Schriften*, ed. Daniel Runge, II, Hamburg, 1840, p. 208.

20. 'Indigena' (J. J. Grümbke), *Streifzüge durch das Rügenland*, Altona, 1805, pp. 96–7. Cape Arkona occupied a special place in the iconography of the Nordic Renaissance since it was the site of a temple to the Wend deity Swantewit until its destruction in 1168 by Waldemar I of Denmark.

21. *Jenaische Allgemeine Literatur-Zeitung*, III, 1806, pp. i–xii. See also Walther Scheidig, *Goethes Preisaufgaben für bildende Künstler, 1799–1805*, Weimar, 1958, pp. 454, 455, 477–88, 495, 522, note 399.

22. See Walter Koschatzky, *Die Kunst der Zeichnung. Technik, Geschichte, Meisterwerke*, Munich, 1981, pp. 142–3.

23. Runge, op. cit., II, p. 208. Friedrich composed two poems entitled *Morning* and *Evening* at about this time.

24. On this subject, see especially Erika Platte, *Caspar David Friedrich. Die Jahreszeiten*, Stuttgart, 1961.

25. See Eva Reitharová and Werner Sumowski, 'Beiträge zu Caspar David Friedrich', *Pantheon*, 1977, pp. 44–7.

26. Marie Helene von Kügelgen, *Ein Lebensbild in Briefen*, Leipzig, 1900, p. 146.

27. *Zeitung für die elegante Welt*, nos 12–15, 19–21 January 1809, pp. 91–4, 97–102, 105–10, 113–18. Quoted in full in Hinz, op. cit., pp. 138–57.

28. *Journal des Luxus und der Moden*, April 1809, p. 239. Quoted in Hinz, op. cit., p. 137.

29. Christian August Semler, 'Über einige Landschaften des Malers Friedrich in Dresden', *Journal des Luxus und der Moden*, February 1809, p. 233.

30. See BS/J, p. 303.

31. Ibid.

32. 'Verschiedene Empfindungen vor einer Seelandschaft von Friedrich, worauf ein Kapuziner', *Berliner Abendblätter*, 13 October 1810, p. 47. Quoted in Hinz, op. cit., pp. 222–6.

33. Carl Gustav Carus, *Lebenserinnerungen und Denkwürdigkeiten*, II, Leipzig, 1865, p. 230.

34. Quoted in E. Cassirer, *Künstlerbriefe aus dem 19. Jahrhundert*, Berlin, 1923, p. 61.

35. *Journal des Luxus und der Moden*, March 1811, p. 371. Quoted in BS/J, p. 78.

36. Quoted in BS/J, p. 330.

37. Letter to Ernst Moritz Arndt of 12 March 1814. Quoted in Hinz, op. cit., p. 25.

38. Carl Gustav Carus, *Neun Briefe über Landschaftsmalerei. Geschrieben in den Jahren 1815 bis 1824*, ed. Kurt Gerstenberg, Dresden, n.d., p. 60.

39. Ludwig Richter, *Lebenserinnerungen*, Leipzig, 1950, p. 437.

40. Letter of 11 July 1816. Quoted in Hinz, op. cit., p. 30.

41. See BS/J, p. 340.

42. Carl August Böttiger, 'Werke hiesiger Maler', *Artistisches Notizenblatt*, 1825, p. 94.

43. Quoted in BS/J, pp. 188–9.

44. Friedrich Pecht, *Aus meiner Zeit*, I, 1874, p. 159.

45. Quoted in Hinz, op. cit., p. 133.

46. On the relationship between Dahl and Friedrich, see especially Marie Lødrup Bang, *Johan Christian Dahl 1788–1857. Life and Works*, I, Oslo, 1987, pp. 73–83.

47. *Der Gesellschafter oder Blätter für Geist und Herz*, 1823, p. 683. Quoted in BS/J, p. 99.

48. See BS/J, pp. 386–7.

49. Henry Jouin, *David d'Angers. Sa vie, son oeuvre*, II, Paris, 1878, p. 320.

# The *Winter Landscape*

## JOHN LEIGHTON

The death of Caspar David Friedrich in 1840 attracted little attention – he was already a forgotten figure with few followers. His art, once the subject of heated controversy, was widely considered to be old-fashioned, and for much of the nineteenth century his works were all but ignored by writers and critics. During this long period of neglect many of his paintings disappeared from view. Some are still unaccounted for today although the gradual reassessment of Friedrich's reputation, which began in the late nineteenth century, has helped to uncover at least some of these missing works. The process of rediscovery accelerated in this century as Friedrich came to be recognised as one of Germany's leading painters and as museums and private collectors competed to acquire examples of his work.

When a small painting of a winter scene (Cat. 18) came to light in Dresden during the Second World War it seemed that yet another lost work by Friedrich had been rediscovered. The picture matched descriptions of a composition that the artist was known to have painted in 1811 and an old inscription on the back of the stretcher seemed to confirm the attribution. No one seriously questioned the authenticity of this work, which was purchased by the Museum für Kunst in Dortmund and which has since been shown in numerous exhibitions and included in most of the subsequent literature on Friedrich.

A more recent discovery cast doubt on the attribution of the Dortmund painting in a most dramatic way. In 1982, an almost identical painting of a *Winter Landscape* (Cat. 17) was found among the possessions of a deceased private collector in Paris. This painting was also attributed to Friedrich and was acquired by the National Gallery in 1987. Here again was a picture which could be matched to nineteenth-century descriptions and whose style displayed the hand of Caspar David Friedrich. Yet as only one version of this composition is recorded in the contemporary literature it now seemed that there were two paintings competing for a single place in the artist's oeuvre.

The unexpected emergence of the National Gallery painting raises several art-historical issues, but the most pressing question concerns its authenticity. Is it a genuine work by Friedrich and how does its claim to this status compare with that of a picture that has hung in a German museum for over forty years?

There are a number of obvious ways to set about answering this question. First of all, the nineteenth-century documents and literature must be re-examined for any possible references that might relate to either the London or the Dortmund painting. Similarly, the recent history of the two pictures might yield some clues that could establish a secure provenance for either work. Finally, it seems essential to examine the pictures for evidence, looking closely at how they compare to other works by Friedrich and employing modern scientific methods of technical analysis where appropriate.

## The History of the Painting

Any attempt to authenticate a work by Friedrich is beset by certain problems. He did not usually sign or date his pictures, left no detailed account books or lists of his works and rarely spoke about or described his paintings. So for the most part we must rely on the recollections of his friends and contemporaries or on exhibition reviews to piece together a fragmentary history for any individual picture.

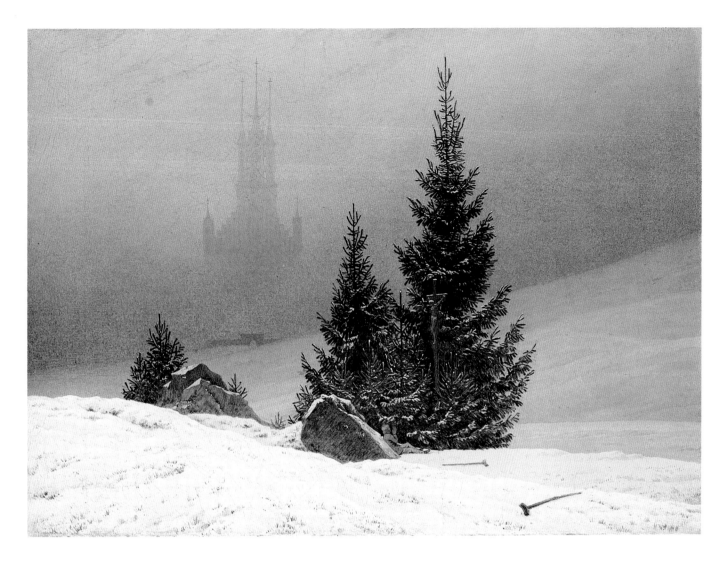

Cat. 17 Caspar David Friedrich, *Winter Landscape*, 32.5 × 45 cm, National Gallery, London

The first recorded references to a *Winter Landscape* appear in the correspondence of two separate visitors to Friedrich's studio in 1811.[1] Both were clearly struck by the small yet intense picture, which they describe in some detail, and both observed that the painting had a pendant, another *Winter Landscape* (Fig. 24), which is now in the Museum in Schwerin, in East Germany.[2] These pictures were first shown to the public at an exhibition in Weimar later the same year, where they attracted the attention of the reviewer for the *Journal des Luxus und der Moden*.[3] The *Winter Landscape* with the 'tall Gothic church' was reported to have 'all the characteristics that continue to distinguish Herr Friedrich's works' and the painting was praised for its 'masterful' execution.

A *Winter Landscape* is mentioned again in the same journal in 1813, this time as the property of a Dr Ludwig Puttrich in Leipzig.[4] A well-known collector

and connoisseur, Puttrich amassed an enormous collection of graphic art, and also owned a number of old-master pictures and some oil paintings by contemporary artists. Later in his career, he was to publish an impressive survey of medieval architecture in Saxony, for which he commissioned several hundred drawings by a large number of artists.[5] The collector's architectural interests may well explain his attraction to the *Winter Landscape* with its distinctive Gothic church, although it is perhaps surprising that Puttrich did not acquire the pendant composition, preferring instead a different work that Friedrich had painted in the same year, the *Landscape with Oak Trees and a Hunter* (Cat. 16, ill. p. 46).

Since the *Winter Landscape* was in such a prominent and apparently accessible collection, one might expect a wealth of references to it. Yet, with the exception of a review of an exhibition held in Leipzig

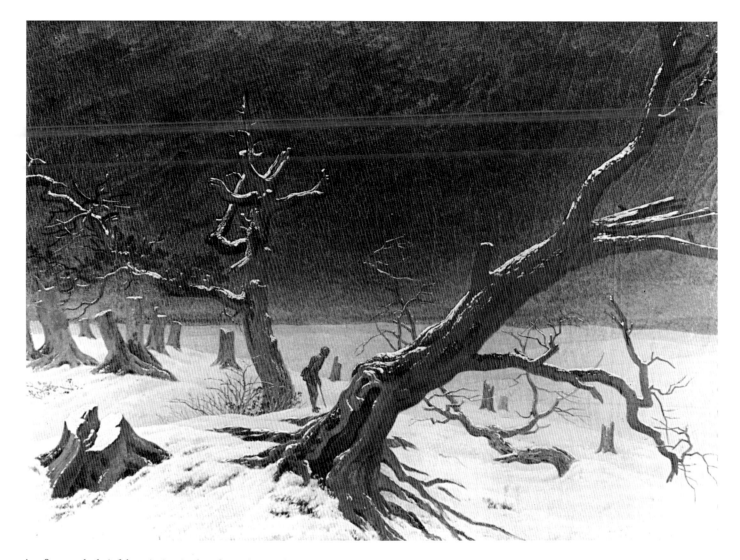

in 1814, and a brief description in the 1817 edition of an encyclopedia published by Puttrich's friend F. A. Brockhaus, there are no further references to the *Winter Landscape* in the known nineteenth-century literature on Friedrich.[6] Puttrich's collection was dispersed at a number of auctions both before and after his death, but there is no mention of a painting by Friedrich in any of the catalogues of these sales.[7]

Although the *Winter Landscape* seems to vanish without trace in the nineteenth century, two early copies of the painting have fortunately survived. The first of these is a watercolour (Cat. 19) by Karl Wilhelm Lieber, who spent a short while in Dresden in 1812 as a student of Friedrich and of Georg Friedrich Kersting. This brief association ended with an unusual quarrel. Goethe later recorded that Friedrich was apparently upset by Lieber's misrepresentative copy of his *Winter Landscape* and the younger

artist was banished from his studio.[8] The copy (now in the Goethe Wohnhaus in Weimar) reveals the possible cause of Friedrich's annoyance, for it is a stylised pastiche without any of the sensitively observed natural effects that are so important to the original. Furthermore, by replacing the cripple with a kneeling figure, Lieber distorts the symbolic content of Friedrich's composition, reducing it to an anecdotal scene.

Lieber's amateurish copy is of little help in establishing whether the London or the Dortmund picture is the original composition of 1811. However, a second work based on the *Winter Landscape* seems to be a reasonably faithful copy and provides a more rewarding comparison. This is a coloured aquatint (Cat. 20) by the Leipzig artist Johann Jakob Wagner, which was exhibited in 1820. A number of small but important details suggest that Wagner's aquatint was

Fig. 24 Caspar David Friedrich, *Winter Landscape*, 33 × 46 cm, Staatliche Museen, Schwerin

based on the London picture. The church in the print closely resembles the building in the National Gallery painting, and includes similar architectural details. Most importantly, Wagner has included the blades of grass appearing through the melting snow in the foreground, a feature that appears only in the London *Winter Landscape*. However, the evidence of the print is not conclusive since Wagner omitted the little gateway leading to the church, a detail clearly visible in the London painting but absent from the Dortmund version.

Wagner's aquatint was exhibited on several occasions during the last century, but there are no further clues to the whereabouts of the original *Winter Landscape*. The Dortmund painting was discovered by a Dresden art dealer around 1940. No records of its earlier provenance have survived, although it is said to have come from a private collection in Teplitz. There is a similarly disappointing lack of information about the National Gallery picture, which was discovered in the collection of a Russian prince who had been living in exile in Paris. Again, no documents have been found to establish how the picture came to be in his possession, but it seems likely that it was one of a number of items which his family had inherited from Prince Grigorii Gagarin, a well-known Russian artist of the nineteenth century.[9] Several works by Friedrich found their way into the collections of the Russian imperial family in the first half of the last century, largely through the efforts of Vassily Andreyevich Zhukovsky (a poet, artist and tutor to the Tsarevich), who befriended the artist in the 1820s and acquired several of his pictures.[10] Zhukovsky was a close friend of the Gagarin family and may have introduced Gagarin to Friedrich's work.[11] It is equally possible that Gagarin could have acquired the London *Winter Landscape* on his travels through Germany, but in the absence of any documentary proof these ideas must remain pure speculation.

## A Technical Comparison

The lack of consistent documentation for either version of the *Winter Landscape* inevitably places great importance on a stylistic and technical comparison of the two works. At first glance it might seem that they are almost identical, yet when they are viewed together a number of important differences become apparent. For example, there are several details in the London picture which do not appear in the Dortmund version. These include the gateway in front of the church and the blades of grass pushing through the snow in the foreground. It is also obvious that the

pictures differ in the way that they are painted. The precise handling of paint in the London picture is quite distinct from the broader, more spontaneous style of the Dortmund painting. A comparison of a single detail in the two pictures illustrates this basic difference in approach. The church in the London picture is carefully drawn and it is possible to see a considerable number of architectural features. By contrast the church in the Dortmund *Winter Landscape* is a sketchily painted silhouette.

The different characteristics of the two versions of the *Winter Landscape* are very revealing, for it is the style of the London painting which relates more closely to other early works by Friedrich. The present exhibition offers an opportunity to compare both pictures with a number of other relevant works, including drawings and sepias as well as oil paintings. It is important to emphasise the unusual and quite distinctive methods that characterise these works. Friedrich began to work in oils when his artistic career was already firmly established and it is unlikely that he had ever received much formal training in the techniques of this medium. In his first oil paintings therefore he simply adapted the methods and procedures which he had already perfected as a draughtsman.[12] For example, in *Mist* (Cat. 14, ill. p. 38), one of the artist's earliest known oil paintings, Friedrich uses a technique which he had practised for several years in his sepia drawings. Instead of exploiting the variable densities and thicknesses of the oil paint, he has applied it in thin transparent washes over a delicate underdrawing. A range of marks and patterns are used to convey the different forms and surfaces of nature: the sea is depicted with small strokes laid side by side like a closely woven textile; the rocks are laid in with longer hatched strokes; and the hazy quality of the mist is captured by careful stippling with the point of the brush.

Friedrich's skilful and meticulous technique was often admired by his contemporaries. Perhaps the best eyewitness account of the artist at work was provided by his friend, Carl Gustav Carus:

> He never made sketches, cartoons or colour studies for his paintings, because he claimed (and certainly not without reason) that imagination tends to cool down through such aids. He never began a painting until it stood lifelike in his imagination, then he drew onto the neatly stretched canvas, first lightly with chalk and pencil, then the whole of it properly and definitely with a quill pen and Indian ink, and soon proceeded to lay on the underpainting.[13]

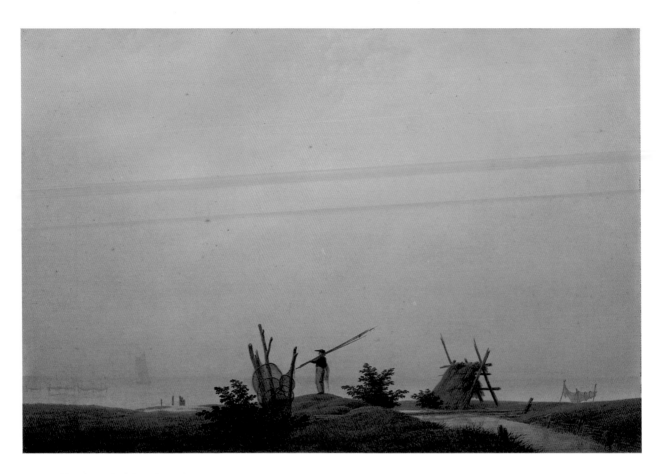

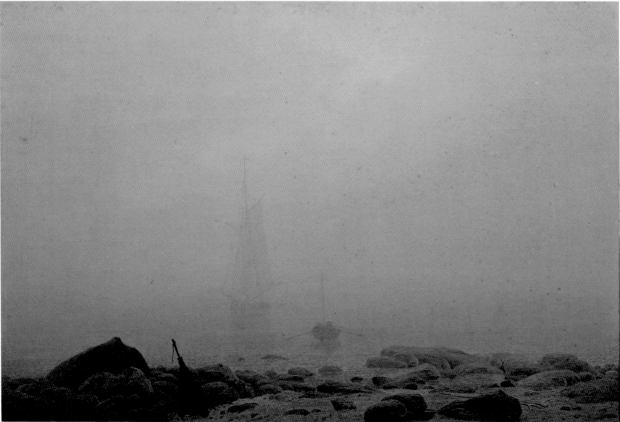

Cat. 13 Caspar David Friedrich, *Seashore with Fisherman*, 34.5 × 51 cm, Kunsthistorisches Museum, Neue Galerie, Vienna

Cat. 14 Caspar David Friedrich, *Mist*, 34.5 × 52 cm, Kunsthistorisches Museum, Neue Galerie, Vienna

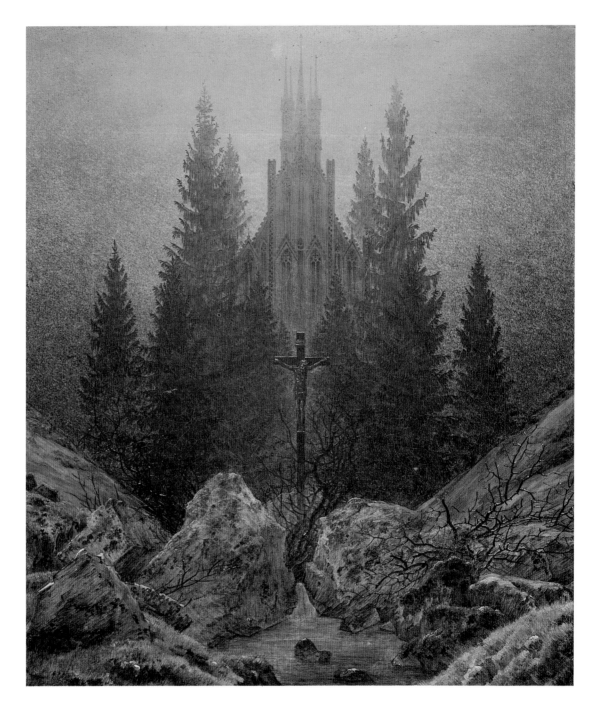

Cat. 21 Caspar David Friedrich, *Cross and Cathedral in the Mountains*, 44.5 × 37.4 cm, Kunstmuseum, Düsseldorf

Carus was closest to Friedrich in the 1820s but the rigorous procedures which he observed seem equally relevant to the earlier works. The London *Winter Landscape* was painted in precisely the manner that Carus describes and an infra-red reflectogram (Fig. 25) reveals the elaborate drawing that underlies the paint surface. In some areas of the picture it has been possible to detect two separate layers of drawing – it seems that the basic structure of the church was first drawn out with ruled pencil lines which were then reinforced with thicker, darker lines (presumably in pen and ink) that are allowed to show through the final paint layer.

*Cross and Cathedral in the Mountains* (Cat. 21, ill. p. 39), usually dated to around 1812, provides a particularly useful comparison to the style of the National Gallery *Winter Landscape*. A similar set of components, including fir trees, rocks and crucifix, has been reassembled into an even more hieratic and symmetrical composition, dominated by the façade of a Gothic church rising out of a mist. As in the London painting an elaborate underdrawing is still partly visible through the final paint layer. In both pictures there are subtle variations in the handling of the paint which help to evoke a range of natural effects. The fir trees are thinly painted with short, hatched strokes, whereas a slight impasto recreates the melting snow in the foreground; for the mist in the background Friedrich adopts his characteristic stippling technique.

The *Winter Landscape* in Dortmund does not fit so readily into the pattern of Friedrich's work around 1811. No underdrawing is visible in an infra-red photograph of the Dortmund painting, a fact that immediately sets it apart from the other works by Friedrich which have been subjected to technical photography.[14] The paint surface is more even and in some areas, including the bank of snow in the background on the right, the paint appears to have been rapidly applied. In general, it is more freely painted than the London picture and there is less evidence of the deliberation and care that is so characteristic of Friedrich's early work.

## The Problem of Variants, Versions and Copies of Friedrich's Work

There seems little room for doubt that the National Gallery *Winter Landscape* is the picture which Friedrich is known to have painted in 1811. The technical data (including the infra-red photographs and the details of the materials used in the painting) add significant weight to the visual and historical evidence

that supports the attribution. It is more difficult to reach a definite conclusion about the status of the Dortmund painting. There are other works by Friedrich which exist in more than one version and although some of these are clearly copies there are other cases where the authorship has been the subject of considerable debate. The process of sifting the work of Friedrich from that of his pupils and followers seems far from complete and the discovery of the National Gallery picture has reopened this problematic issue.[15]

Friedrich often produced variations on his own compositions. This practice emerged early on in his career with the reworking of certain motifs in his sepias. The sepia *Cape Arkona at Sunrise* (Cat. 3) is known to have existed in at least five versions, of which only two have survived. Although the basic composition remains constant in these versions, Friedrich alters several details and introduces substantial changes to the general mood and effect of the image. When Friedrich took up oil painting he continued to explore the different possibilities of favoured compositional formats. An early painting

Fig. 25 Infra-red reflectogram mosaic of the central portion of *Winter Landscape* (Cat. 18, ill. p. 35) showing the drawing beneath the paint layer

entitled *Winter* (Fig. 28) reworks a composition that first appears in a sepia of 1803. In turn, the oil painting provided a prototype for several subsequent works including the *Abbey among Oak Trees* (Fig. 8). Towards the end of his career, he returned to the original image with a sepia now in Hamburg (Cat. 4).

This creative reassessment of his own work is central to Friedrich's approach, but is quite distinct from the notion of merely reproducing past successes. If Friedrich did do this it can only have been on rare occasions, for the number of replicas is small. A group of pictures which provide a useful comparison to the problem are the four versions of the *Cross on the Baltic* (Cat. 22, ill. p. 42, and 23), one of which was recently rediscovered and was acquired by the Verwaltung der Staatlichen Schlösser und Gärten in Berlin. As in the case of the *Winter Landscape*, the various paintings of the *Cross on the Baltic* might appear to be quite similar. However, there is one telling detail which sets the Berlin picture apart from its rivals. In the foreground, a cluster of poles and a boat hook are wedged behind a rock. The other paintings have a similar foreground except that the poles have been replaced by tautened ropes leading out of the right-hand edge of the composition. Yet in a sketch of this composition (Fig. 26), which Friedrich included in a letter to a friend, it is the poles and the boat hook which are depicted, not the ropes. This important piece of evidence supports the suggestion that the Berlin painting (Cat. 22) is by Friedrich whereas the other paintings are copies which show a misunderstanding of his intentions.

For some Friedrich scholars the idea of the artist producing replicas of his work runs counter to the notion of the creative genius producing unique masterpieces. The artist himself rarely commented on his working methods but his few recorded statements comply with the Romantic cult of originality. He tended to emphasise that a work of art is the expression of a personal inner vision and that its realisation is something like a religious experience.[16] It is not clear whether this mysterious and introspective creative act could embrace the rather more mechanical process of duplicating his own work, but it is possible that practical considerations may have encouraged him to reproduce a popular image. Johan Christian Dahl recorded that Friedrich received commissions for replicas of one of his best-known compositions, the Dresden *Two Men Contemplating the Moon* (Cat. 24, ill. p. 43). There are two further versions of this subject (now in private collections) which could conceivably be by Friedrich (Cat. 25).[17]

In general, however, there is very little documentary evidence to support the attribution of the various replicas to Friedrich rather than to pupils or imitators, and after the discovery of the National Gallery painting, the *Winter Landscape* in Dortmund must now join this group of disputed works. There is only a limited number of possible explanations for the existence of this picture. It could be a study or a replica by Friedrich himself, or a copy by a pupil, follower or imitator. The possibility that the Dortmund painting is a preparatory study can probably be ruled out since Friedrich does not seem to have produced intermediate studies in oil. It is more likely that Friedrich may have had some compelling reason to paint a second version of this particular composition. The two paintings are certainly similar enough to suggest that the Dortmund picture must have been produced with the original model to hand. As the date inscribed on the stretcher implies, this would mean that it was painted in 1811 before the London picture left Friedrich's studio. The most likely hypothesis, however, is that the Dortmund picture is a copy by another hand. The inscription on the back of the stretcher need not contradict this view. This is usually taken to be the date when the Dortmund painting was acquired by its first owner, but it could perhaps have been written by a copyist recording the date of completion of his work.[18] There are plenty of clues throughout the painting which betray a rather less fastidious technique than that of Friedrich. For example, the crooked silhouette of the church in the Dortmund picture seems to be a misreading of the same detail in the National Gallery painting. In the latter the church only appears to be asymmetrical because the tower is set slightly back from the façade.

Further information may yet emerge to shed light on these problems of attribution. Recent research offers a clearer picture of the artistic personalities working in Friedrich's circle in Dresden.[19] Similarly, an increasing amount of detailed scientific information about Friedrich's work is becoming available and this is an obvious line of enquiry which has still to be fully explored. Nevertheless, these questions will probably remain within the realm of traditional connoisseurship and will continue to involve a detailed scrutiny of the paintings. By bringing together a number of paintings by Friedrich with their disputed variants it is to be hoped that the present exhibition will facilitate this process.

## The Subject of the *Winter Landscape*

Towards the end of 1811 Friedrich sent nine of his paintings to an exhibition in Weimar.[20] This was the

Fig. 26 Caspar David Friedrich, *Cross on the Baltic*, pen and ink, Bonn University Library

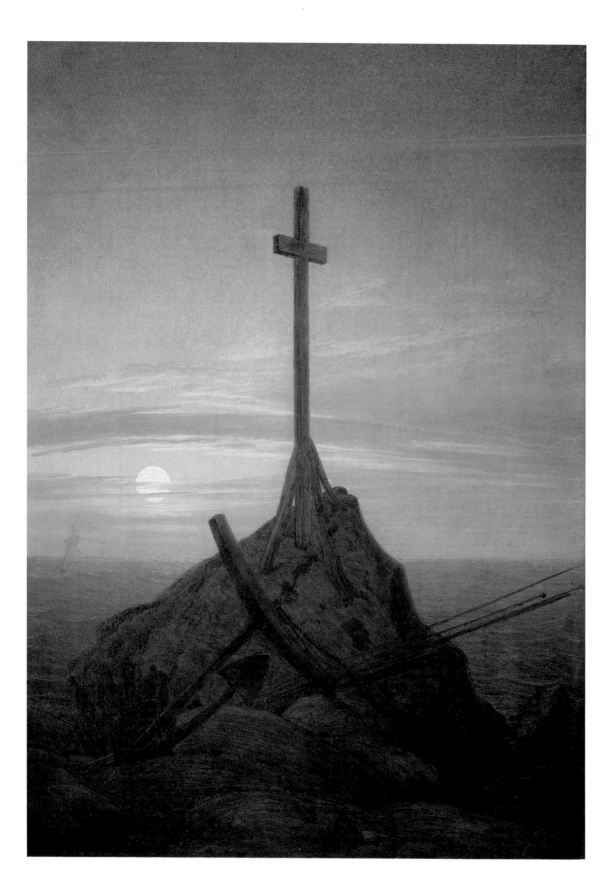

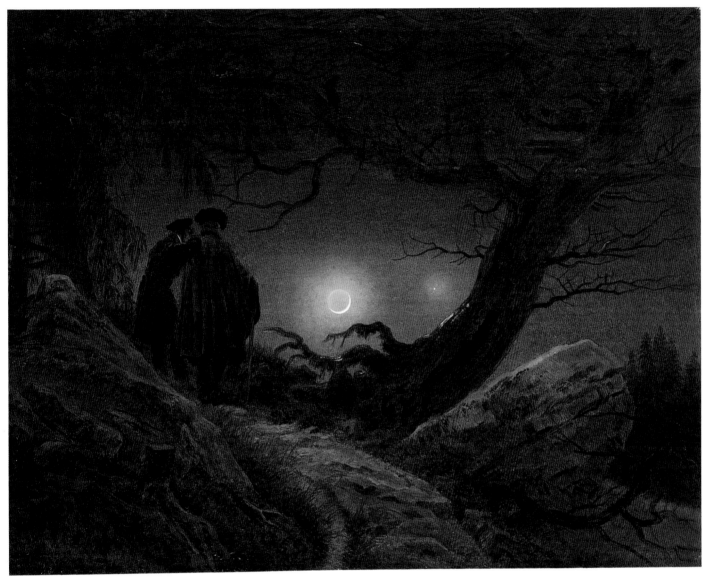

Cat. 22 Caspar David
Friedrich, *Cross on the
Baltic*, 45 × 32 cm,
Verwaltung der
Staatlichen Schlösser
und Gärten, Schloß
Charlottenburg, West
Berlin

Cat. 24 Caspar David
Friedrich, *Two Men
Contemplating the Moon*,
35 × 44 cm,
Gemäldegalerie Neue
Meister, Dresden

largest showing of his work to date and represented the culmination of a particularly productive period in his career. The selection of paintings which he submitted demonstrated the range and diversity of his recent landscapes. Some of these would have seemed quite traditional, like the *Landscape with Oak Trees and a Hunter* (Cat. 16, ill. p. 46), which is a fresh, sunlit view obviously indebted to seventeenth-century Dutch art. Alongside the conventional works, however, there were also examples of Friedrich's more innovative and challenging imagery, including the *Winter Landscape* (Cat. 17).

Most of Friedrich's works in the Weimar exhibition seem to have been conceived in pairs, and so the London picture was probably displayed beside another *Winter Landscape* now in Schwerin (Fig. 24).[21] To a public versed in the picturesque conventions of eighteenth-century landscape painting these two works must have seemed quite astonishing. The Schwerin painting in particular is a bleak and uncompromising image. At the centre of the composition, a tiny figure on crutches stares out across an empty snow-covered plain. He is surrounded by the twisted trunks of dead or dying oak trees and by rows of tree stumps stretching into the distance. Viewed in isolation it would be hard to imagine a more desolate prospect. It is clear, however, that the two paintings were intended to be read in sequence and the apparent pessimism of the first picture is countered by its pendant, the National Gallery *Winter Landscape*. The cripple appears again, but now his crutches lie abandoned in the foreground and he sits against a rock with his hands raised in prayer before a shining crucifix. On the horizon the façade of a Gothic church appears like a vision out of a bank of mist.

Friedrich's rigorous observation of natural phenomena is apparent in these two paintings. The textures of soft, decaying wood or of melting snow are captured with the convincing skills of an artist who has spent many hours studying from nature. This is confirmed by the existence of at least two earlier drawings after nature which the artist used as raw material for the compositions (Fig. 27 and Cat. 11). Yet it would be difficult to mistake the pictures for straightforward records of the countryside – with their simple, formal compositions, devoid of any distracting detail, it seems immediately obvious that these haunting images are rich in symbolism.

Friedrich's symbolism is often ambiguous and difficult to interpret, but in the two Winter Landscapes a basic theme is expressed with unusual clarity. If the Schwerin painting may be read as an image of

despair and hopelessness in the face of impending death, then the National Gallery picture evokes the promise of salvation through the Christian faith. The traditional meaning of the crucifix is reinforced by the contrasting natural forms in the two works. The tangled, stunted limbs of the dead trees in the first painting are compared with the vigorous growth of the upright young fir trees in the companion piece. Fresh shoots of grass pushing through the snow in the London painting and a sky streaked with the pink and orange glow of dawn confirm the parallel between the

Fig. 27 Caspar David Friedrich, *Fir Trees* (detail), pencil, 36.6 × 24 cm, National Gallery, Oslo

reawakening of nature and the presence of the Divine.

The different compositions of the two paintings underline the religious content. In the Schwerin *Winter Landscape* the confused arrangement of twisted, skeletal trees conveys an impression of chaos and disorder. This is replaced in the pendant by a

earthly and the spiritual, between the natural and the supernatural. The gate in front of the church marks the crossing point between these two realms. This is a recurring element in Friedrich's symbolism and may be confidently interpreted as the gate of death which leads to the hereafter.[23]

The Schwerin and London pictures develop and

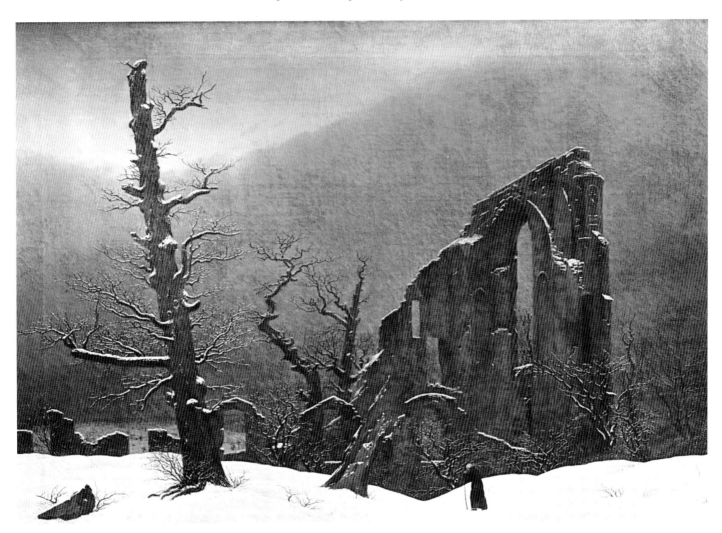

Fig. 28 Caspar David Friedrich, *Winter*, 73 × 106 cm, formerly Neue Pinakothek, Munich (destroyed in 1931)

simpler and more organised structure. The format is one that Friedrich frequently adopts in works in which he attempts to depict a visionary revelation.[22] Instead of leading the spectator's eye in gentle stages from the foreground through the middle distance to the background, he divides the picture space into two distinct planes, creating an abrupt opposition between near and far. Whereas the crisply modelled forms in the foreground seem accessible and tangible, the mysterious silhouette of the church is remote and ethereal, as if to suggest the difference between the

refine a set of symbols and associations which had preoccupied the artist for over a decade. In its stark and melancholy imagery, the first painting in the sequence relates back to works like the *Winter* of 1807 (Fig. 28), in which a solitary monk makes his way through the graveyard of a ruined Gothic abbey, overshadowed by the remains of frozen, lifeless trees. The London *Winter Landscape* has an even longer pedigree and the basic theme of the crucifix in a landscape setting may be traced back to his earliest works.

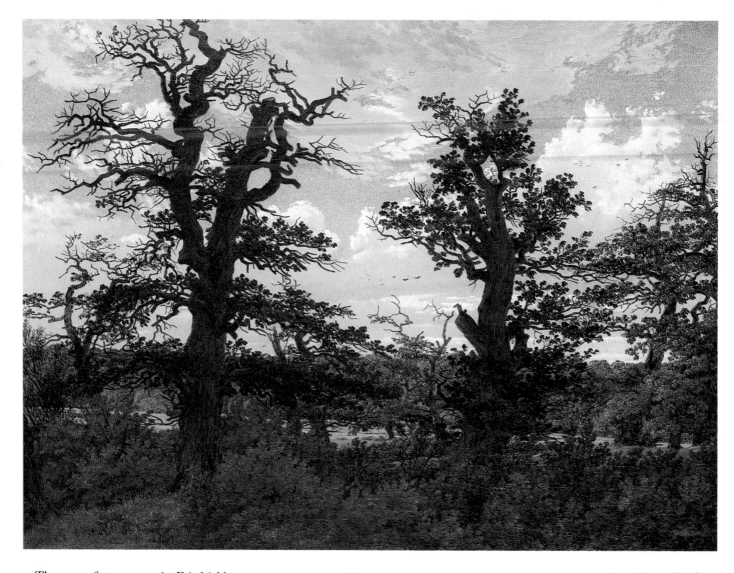

The cross first appears in Friedrich's art as an unimportant feature within the landscape. The tiny crosses that punctuate views like the *Landscape with an Obelisk* (Cat. 8) are included as topographical elements without any direct symbolic overtones. In other early works, however, the crucifix takes on a more obvious significance. A small sepia drawing of Eldena Abbey (Kupferstichkabinett, Dresden), usually dated to about 1800, includes the crucifix as the single symbol of hope within a wintry graveyard that includes the familiar ruins, broken trees and a funeral processing through a gate in the distance. Later, in a number of sepias which date from between 1805 and 1807, the cross is the central feature. In one of these, *Coastal Landscape with Cross and Statue*, in the Nationalgalerie, East Berlin, a cross is placed at the focal point of the composition, framed by a group of

trees whose tops intertwine to form a natural arch. Silhouetted against the sky, it articulates the mystical atmosphere which permeates the entire landscape.[24]

There is nothing original in Friedrich's use of the cross as a feature in his landscapes. As a wayside shrine or as a comforting symbol set high on a hill, it is a common accessory in landscape painting of all periods.[25] A sepia drawing by one of Friedrich's mentors in Dresden, Adrian Zingg, provides an interesting parallel (Fig. 29). Here a kneeling traveller prays before a small wooden Madonna and a cross hewn out of the trunk of a dead tree. The illumination of this centrally placed group by the diagonal rays of the sun lends a visionary quality to an awe-inspiring scene. Yet these religious trappings seem to be grafted onto a landscape which is in essence a fairly accurate rendering of a spectacular mountain range in

Cat. 16 Caspar David Friedrich, *Landscape with Oak Trees and a Hunter*, 32 × 44.5 cm, Museum Stiftung Oskar Reinhart, Winterthur

the artist's native region of Saxon Switzerland.[26] In works like the *Winter Landscape*, however, Friedrich expands a traditional landscape accessory into a subject in its own right. The symbolism of the crucifix becomes the key to understanding a work in which all the natural forms must play a supporting role.

man in Him, the crucified'. The sinking sun of *The Cross in the Mountains* is replaced by the light of dawn in the *Winter Landscape*, but in both pictures the role of the crucifix remains the same. Reflecting the light of the sun, the gilded relic is placed at the centre of the picture as a resonant symbol of salvation.

Fig. 29 Adrian Zingg, *The Prebischkegel in Saxon Switzerland*, sepia wash, 51.4 × 68.4 cm, Kupferstichkabinett, Dresden

Of the numerous precedents in Friedrich's own art for the imagery of the *Winter Landscape*, the most direct is *The Cross in the Mountains* (Fig. 6). The emblematic appearance and the explicit symbolism of this picture represent an extreme form of Friedrich's imagery, but he continued to explore similar themes in subsequent works, although these are usually on a more intimate scale and are rarely as severe and imposing. Nevertheless, there are clear echoes of the hieratic structure of *The Cross in the Mountains* in the strict, symmetrical arrangement of the *Winter Landscape*. Similarly, the explanation of the earlier picture, which C. A. Semler outlined on Friedrich's behalf, includes ideas which seem equally appropriate to the National Gallery painting.[27] The rocks are to be seen as unshakeable symbols of faith, as are the evergreen fir trees, 'enduring through all ages like the hopes of

Most of the components in the *Winter Landscape*, including the crucifix, rocks and fir trees, are standard features of Friedrich's pictorial language, but the inclusion of the Gothic church in the background is a new departure. Gothic buildings often appear in Friedrich's early work but they are usually shown in a state of ruin. Sometimes the crumbling remains are surveyed with the objective eye of a topographical artist, as in a number of drawings depicting the ruins of the Cistercian abbey of Eldena near his home town of Greifswald.[28] More often they are transformed into images of dramatised decay, symbolising the passing of ancient religions and evoking the fragility of man's existence on earth. In the faint silhouette of the church that emerges from the mist in the *Winter Landscape*, Gothic architecture takes on a quite different significance as a symbol of restoration and

renewal.[29] Some of the details of the structure probably derive from buildings that Friedrich knew well and had studied often in drawings and sketches. The shape of the façade may even be based on the cathedral of Meissen near Dresden.[30] Yet Gothic archeology had only a limited appeal to Friedrich, and the cathedrals which appear frequently in his work are usually imaginative constructions, invented to suit his own pictorial purposes.

The inclusion of a neo-Gothic church as a religious symbol in the *Winter Landscape* echoes ideas which were often expressed in German literature of the late eighteenth and early nineteenth centuries. As early as 1772 the youthful Goethe set the tone for the Gothic revival in Germany in his brief essay inspired by Strasbourg Cathedral, 'On German Architecture'. The Gothic is branded as the true German style, with Goethe comparing the cathedral to 'a sublimely towering tree of God which ... proclaims to the surrounding country the glory of its master, the Lord.'[31] This emotive association of Gothic architecture with an organic style that was the product of a devout Germanic people formed a compelling myth which was developed by numerous writers around the turn of the century.[32] The notion that medieval architecture was originally inspired by natural forms had a particular appeal; the writer, Ernst Moritz Arndt, was to compare the experience of visiting St Sebald's in Nürnberg to 'standing in a forest of sacred firs'.[33]

Friedrich restates these analogies in a visual form in the *Winter Landscape*. The silhouette of the church mirrors the shape of the foreground trees and the delicate tracery is likened to petrified branches and leaves. This organic simile is reworked in an even more dramatic form in the Düsseldorf *Cross and Cathedral in the Mountains* (Cat. 21, ill. p. 39), where the cathedral seems to rise upwards out of the rocks and fir trees. These abstract, weightless structures that float on the horizon appear more visionary than real, presenting 'an image of infinity'.[34]

Friedrich's Gothicism relates in a general way to a wider preoccupation in Romantic art and literature. But his interest in visionary Gothic architecture, which appears first in the *Winter Landscape*, may well be a response to a specific mood in German art and literature. By the end of the first decade of the nineteenth century, the taste for Gothic was well established in the visual arts. An interest in themes drawn from German medieval history was sharpened by a growing sense of nationalism throughout the period of the Napoleonic wars.[35] It is perhaps ironic

that this Gothic mood was promoted above all in the work of Karl Friedrich Schinkel, an architect with a thorough grounding in classicism. When commissions for buildings were scarce during the period of French domination, Schinkel's energies were mainly devoted to painting and printmaking. As an artist he is perhaps best known for his imaginative townscapes where soaring cathedrals and castles dominate bustling medieval cities in pictures which seem part fairy tale, part historical fantasy.

Paintings by Friedrich such as *Abbey among Oak Trees* (Fig. 8) are sometimes cited as the source for these works, but Schinkel had already shown an independent interest in the Gothic revival.[36] In 1809 he painted a large decorative picture which juxtaposes medieval ruins with a neo-Gothic cathedral in an Italianate setting.[37] At the Berlin Academy exhibition of the following year he showed a lithograph of a cathedral nestling among oak trees with the caption: 'An attempt to express the sweet yearning melancholy with which the heart is filled by the tones of a religious service resounding from a church' (Fig. 30). At the same exhibition Schinkel revealed his plans for a projected memorial to the much mourned Queen Luise of Prussia. For this focus of national pride he

Fig. 30 Karl Friedrich Schinkel, *The Church among Trees*, lithograph, 48.9 × 34.2 cm, Kunsthalle, Bremen

had designed a simple, dignified mausoleum in the Gothic style. Schinkel gave full play to the natural metaphor: within the interior, tree-like columns grew into ribbed vaults decorated with spreading palm leaves, while the mausoleum was to be sited at the end of an avenue lined with fir trees.[38]

It is not known whether Friedrich visited the 1810 Berlin exhibition where his works provoked a critical scandal. But although he may not have seen Schinkel's actual designs for the monument to Queen Luise, he could certainly have read the architect's comments in the accompanying catalogue. Particularly interesting is Schinkel's description of the Gothic style as 'a free idea rising above material needs'. The idea that Gothic architecture could somehow express the triumph of the spirit over the material may well have been in Friedrich's mind when he came to paint the *Winter Landscape* a few months later.[39]

This shared attitude to the Gothic in the work of Friedrich and Schinkel raises an important question. Were Friedrich's images of visionary cathedrals coloured by the nationalistic associations of the Gothic style? It certainly seems unlikely that Friedrich would have been unaware of what was by 1811 a well-worn myth that the Gothic was a true product of German soil. Similarly, it is perhaps no coincidence that the period of Friedrich's deepest interest in the Gothic (from around 1811 to the early 1820s) corresponds to the time when his association with the patriotic and democratic movement is quite well documented. Friedrich's sympathies are apparent in his friendship with several leading patriots and through a handful of paintings which may be read as political statements.[40] Although this nationalistic spirit comes to the fore in Friedrich's art during the Wars of Liberation (1813–15), he had already painted at least one picture, *Eagle above the Mist*, in which he alluded to the difficulties of the German states during the Napoleonic period. According to Gotthilf Heinrich von Schubert, Friedrich intended to express the 'German spirit' rising out of the storm and the clouds.[41] If the artist was prepared to exploit a traditional patriotic emblem it is conceivable that in the *Winter Landscape*, where the faith of a cripple is rewarded by a vision of a triumphant Gothic church, the imagery stems from a particular sentiment which places national rejuvenation alongside religious revival.

In this context it is interesting to return briefly to the copy of the *Winter Landscape* painted around 1812 by Karl Wilhelm Lieber. It has already been noted that this copy is a free reworking of Friedrich's picture and that it provoked a row between the master and his pupil. Although Lieber follows the basic composition of Friedrich's work he introduces one important variation by replacing the ailing cripple with an apparently healthy young man. A closer look reveals that this figure seems to be dressed in *altdeutsche* costume with his large, floppy hat on the ground beside him. This traditional dress was revived during the first decade of the nineteenth century and came to symbolise the German patriotic movement.[42] On the eve of the Wars of Liberation, Lieber painted a figure in German costume kneeling before a crucifix to invoke divine assistance for his cause. What is perhaps latent in Friedrich's original picture is here made explicit and Lieber has transformed a subtle image of regeneration and salvation into a crude political allegory.[43]

It seems possible to offer a number of differing interpretations of the *Winter Landscape*, ranging from general religious themes to specific statements of the artist's personal faith or even patriotism. It may be counted among his most emblematic pictures, yet perhaps we should be wary of searching too closely for particular definitions or for hidden allusions in Friedrich's imagery. The critic who described Friedrich's work at the Weimar exhibition in 1812 was not at all perturbed by any symbolic content in the work and was content to praise the artist's skilful evocation of natural phenomena.[44]

Similarly, if the Schwerin and London paintings seem to be mutually dependent, with an understanding of one presupposing a knowledge of the other, it should be remembered that the artist was later prepared to part with the second picture in the sequence and to send the first for exhibition as an autonomous image. Friedrich himself rarely stated any programme for his pictures, but seems rather to have exploited possible ambiguities and different layers of meaning in his symbolic vocabulary. 'In every subject', he wrote, 'there lies an infinite number of meanings. . . .'[45]

For Friedrich, art was a language of feeling, and, just as he stressed the importance of the artist's inner vision, it would be characteristic of him to emphasise the subjective reaction of each individual when viewing his work. Ultimately, paintings like the National Gallery *Winter Landscape* are intended to evoke moods and emotions and not to describe ideas or religious dogma. The artist does not dictate our response but in this sincere and intimate painting offers us an image for quiet contemplation.

NOTES

The abbreviation BS/J refers to Helmut Börsch-Supan and Karl Wilhelm Jähnig, *Caspar David Friedrich: Gemälde, Druckgraphik und bildmäßige Zeichnungen*, Munich, 1973.

1. The first reference to the *Winter Landscape* is in a letter from the Dresden artist, Gustav Heinrich Naeke to Dr Ludwig Puttrich, 9 June 1811, cited in BS/J, pp. 212–13. The painting is described again in detail in a letter, dated 22 June 1811, from Friederike Volkmann to Dr Christian August Heinroth (a psychiatrist and Professor of Medicine in Leipzig). See Ludwig Volkmann, *Die Jugendfreunde des 'Alten Mannes'. Johann Wilhelm und Friederike Tugendreich Volkmann, nach Briefen und Tagebüchern*, Leipzig, 1925, p. 234; see also BS/J, pp. 175–6. Friederike Volkmann was well known in artistic circles in Dresden and visited Friedrich's studio on a number of occasions.

2. BS/J, No. 193, p. 316. The Schwerin painting was exhibited in Weimar, 1811; Dresden, 1812; and probably Berlin, 1812. There are no further records of this picture until 1941 when it was discovered in Schwerin. It is described in detail in Paul Ortwin Rave, 'Zwei Winterlandschaften C.D. Friedrichs', *Zeitschrift für Kunstwissenschaft*, V, 1951, pp. 229–34.

3. 'Ausstellung von Gemälden und Zeichnungen Weimar am 2. Januar 1812', *Journal des Luxus und der Moden*, 1812, pp. 115–20; an excerpt from this review is cited in BS/J, p. 79.

4. 'Über einige Gemäldesammlungen von Privatpersonen in Leipzig', *Journal für Luxus, Mode und Gegenstände der Kunst*, February 1813, pp. 94–103, cited in BS/J, p. 82. In the Leipzig Directory for 1813 Dr Ludwig Puttrich (1783–1856) is listed as a lawyer and notary. With C. G. Boerner, he was co-founder of the *Leipziger Kunstverein*. See *Allgemeine Deutsche Biographie*, XXVI, Leipzig, 1888, pp. 779–80; Albert Giesecke, 'Ludwig Puttrich, dem Entdecker mittelalterlicher obersächsischer Baukunst, zum Gedächtnis', *Sächsische Heimatblätter*, 1, 1958, pp. 407–11.

5. Dr Ludwig Puttrich, *Denkmale der Baukunst des Mittelalters in Sachsen*, 4 vols, Leipzig 1836–43. This lavish series was financed by subscription although Puttrich himself seems to have borne much of the cost. In 1848 he sold a large part of his collection, apparently to raise funds to complete the publication of this work. The various artists who worked on the project are described in Friedrich Schulze, 'Romantische Lithographie (Puttrich's Denkmäler)', *Archiv für Buchgewerbe und Gebrauchsgraphik*, 12, 1942, pp. 507–11. These included Albert Emil Kirchner (1813–85) who had earlier been a pupil of Friedrich in Dresden.

6. 'Ueber die Leipziger Gemälde-Ausstellung zum Besten verarmter Dorfbewohner. Ostermesse 1814', *Journal für Literatur, Kunst, Luxus und Mode*, 29, 1814, pp. 535–8, cited in BS/J, p. 82; F. A. Brockhaus, *Conversations-Lexicon oder enzyclopädisches Handwörterbuch für gebildete Stände*, 3, Leipzig, 1817, pp. 914–15, cited in BS/J, p. 87. In a letter to Puttrich written in 1819 Friedrich mentions another *Winterbild* which he described as 'almost ready'. However, this painting is probably the destroyed *Chapel in Winter* (BS/J, No. 254) which was completed in that year; see K. W. Jähnig, 'Zwei Briefe Caspar David Friedrichs', *Kunst und Künstler*, XXVI, 1928, pp. 103–9.

7. Frits Lugt, *Répertoire des catalogues de ventes publiques*, I, 1938, no. 9438a (Leipzig, 17 September 1818); II, 1953, no. 19023 (Leipzig, 15 May 1848); no. 19663 (15 February 1850); no. 23133 (London, 20 August 1856); no. 23708 (Leipzig, 22 June 1857); no. 23781 (Munich, 26 October 1857); see also Johann Gottlob von Quandt, 'Die Versteigerung von Dr Puttrich's Kunstbibliothek und Kunstsammlung', *Kunstblatt*, 23, 11 May 1848, p. 41.

8. Letter from Goethe to Heinrich Meyer, 2 January 1813; see Kurt Karl Eberlein, 'C.D. Friedrich, Lieber und Goethe. Mit einem wiedergefundenen Winterbild Friedrichs', *Kunst-Rundschau*, 1, January 1941, pp. 5–7.

9. The son of Prince Grigorii Gagarin, Russian ambassador to Rome and Munich, Grigorii Grigorievich Gagarin (1810–98) trained in Rome 1816–32. In the later 1830s he was sent on diplomatic missions to Munich and Constantinople. Later, Gagarin became vice-president of the St Petersburg Academy of Arts. See A. Savinov, *G.G. Gagarin*, Moscow, 1951; University of Minnesota, Minneapolis, *The Art of Russia 1800–1875*, exhibition catalogue, 1978, p. 51.

10. At least twenty works by Friedrich are known to have passed through Russian collections. Herbert von Einem, 'Wassilij Andrejewitsch Joukowski und C. D. Friedrich', *Das Werk des Künstlers*, Stuttgart, 1939, pp. 169–84. Michael J. Liebmann, 'Shukowski als Zeichner. Neues zur Frage "C. D. Friedrich und W. A. Shukowski"', in Hannelore Gärtner (ed.), *Caspar David Friedrich. Leben, Werk, Diskussion*, Berlin, 1977, pp. 204–9.

11. I am grateful to Lisa Renne and Madame A. V. Kornivlova for this information. One of Zhukovsky's albums of diaries contains a moonlit landscape in the manner of Friedrich, painted by Prince Gagarin. On the collecting of 19th-century German art in Russia see Nikolai Nikulin and Boris Aswaristch, *Deutsche und Österreichische Malerei: Ermitage*, Leningrad, 1986, pp. 55–61.

12. On Friedrich's technique see the essay by Sigrid Hinz, 'Caspar David Friedrich als Zeichner' in Gemäldegalerie Neue Meister, Dresden, *Caspar David Friedrich und sein Kreis*, exhibition catalogue, 1974, pp. 71–89.

13. Carl Gustav Carus, *Lebenserinnerungen und Denkwürdigkeiten*, I, Leipzig, 1865, p. 207.

14. For infra-red photographs of other compositions by Friedrich see Ingo Sandner, 'Besonderheiten der Unterzeichnung auf Gemälden der Romantik' in Heinz Althöfer (ed.), *Das 19. Jahrhundert und die Restaurierung. Beiträge zur Malerei, Maltechnik und Konservierung*, Munich, 1987, pp. 164–75.

15. On the problem of versions see the chapter on 'Echtheitsfragen' in Werner Sumowski, *Caspar David Friedrich-Studien*, Wiesbaden, 1970, pp. 169–79. Further information on individual pictures in Kunsthalle, Hamburg, *Caspar David Friedrich 1774–1840*, exhibition catalogue, 1974.

16. For example, to the Russian poet, V. A. Zhukovsky, he spoke of the inspiration that comes in dreams; 'I am startled, open my eyes, and what my mind was looking

for stands before me like an apparition – at once I seize my pencil and draw; the main thing has been done.' Letter from Zhukovsky to the Grand Duchess Alexandra Fedorovna, 23 June 1821, cited in Tate Gallery, London, *Caspar David Friedrich 1774–1840*, exhibition catalogue by William Vaughan, 1972, p. 108.

17. Other paintings which exist in more than one version are *Swans in the Rushes* (BS/J, Nos 266, 294, 400, 401 and 510); *Neubrandenburg* (BS/J, No. 225 and Sumowski, op. cit., p. 178); *The Sailing Ship* (BS/J, Nos 216 and 217). For the suggestion that BS/J, No. 216, is a copy by Therese aus dem Winckel see Hans Jürgen Hansen, 'Das *Segelschiff* von Caspar David Friedrich', *Zeitschrift für Kunstgeschichte*, 1977, pp. 63–5.

18. The inscription reads: 'Friederich Dresden den 20. Juli 1811'. Although the Dortmund painting does not appear to have been lined it is not on its original stretcher. The inscription is on a piece of wood (assumed to have been part of the original stretcher), and this has been inserted into the new stretcher. The suggestion that the inscription records a date of acquisition is first made by Eberlein, op. cit., p. 6. Eberlein gives several convincing reasons why the inscription is almost certainly not in Friedrich's hand and notes that the *Winter Landscape* was probably already complete by June 1811 (see Note 1). Inscriptions on Friedrich's works are very rare; see Sumowski, op. cit., p. 70.

19. For Friedrich's pupils and followers see the essay by Hans Joachim Neidhardt, 'Caspar David Friedrichs Wirkungen auf Künstler seiner Zeit', in Gemäldegalerie Neue Meister, Dresden, *Caspar David Friedrich und sein Kreis*, exhibition catalogue, 1974, pp. 34ff.

20. See Note 3. In addition to small-scale pictures like the *Winter Landscape* (Cat. 17) and *Mountain Landscape* (Cat. 15), Friedrich also sent two large works, *Morning in the Riesengebirge* (Fig. 9) and *Mountain Landscape with a Waterfall* (BS/J, No. 191, present location unknown).

21. Although the two Winter Landscapes are not mentioned as hanging together in the review in the *Journal des Luxus und der Moden*, 1812, p. 120, they had already been described as pendants by two visitors to Friedrich's studio in 1811 (see Note 1).

22. For a similar format see the *Cross and Cathedral in the Mountains* (Cat. 21) and *Memorial Picture to Johann Emanuel Bremer* (Fig. 15).

23. For the gate as a symbol of death in Friedrich's paintings see Jan Bialostocki, 'Tor und Tod bei Caspar David Friedrich' in Hannelore Gärtner (ed.), op. cit., pp. 155–9.

24. On the recent rediscovery of this sepia see Eva Reitharová and Werner Sumowski, 'Beiträge zu Caspar David Friedrich', *Pantheon*, XXXV, 1977, pp. 41ff.

25. See the introductory essay on Friedrich's crosses in Kunsthalle, Hamburg, *Caspar David Friedrich 1774–1840*, exhibition catalogue, 1974, pp. 56–9.

26. This sepia by Zingg is discussed in Pierpont Morgan Library, New York, *The Romantic Spirit: German Drawings, 1780–1850*, exhibition catalogue, 1988, p. 72.

27. See above p. 15.

28. Otto Schmitt, 'Die Ruine Eldena im Werk von Caspar David Friedrich', *Kunstbrief*, 25, Berlin, 1944.

29. For Friedrich and Gothic architecture see Gerhard Eimer, *Caspar David Friedrich und die Gotik*, Hamburg, 1963; Werner Sumowski, 'Gotische Dome bei Caspar David Friedrich' in Germanisches Nationalmuseum, Nürnberg, *Klassizismus und Romantik, Gemälde und Zeichnungen aus der Sammlung Georg Schäfer, Schweinfurt*, exhibition catalogue, 1966, pp. 39–42.

30. Similar architectural details are used in the cathedral in the Düsseldorf *Cross and Cathedral in the Mountains* (Cat. 21). It has been suggested that the source for these details is the east gable of the Marienkirche in Neubrandenburg; Schmitt, op. cit., p. 5.

31. John Gage, *Goethe on Art*, London, 1980, pp. 105ff.

32. For early nineteenth-century descriptions of the Gothic in Germany see W. D. Robson-Scott, *The Literary Background of the Gothic Revival in Germany*, Oxford, 1965.

33. Eimer, op. cit., p. 22.

34. The Dresden writer Ludwig Tieck used this phrase to describe Strasbourg Cathedral, cited in Nikolaus Pevsner, *Some Architectural Writers of the Nineteenth Century*, Oxford, 1972, p. 12.

35. On the popularity of Gothic themes in painting around 1810 see Helmut Börsch-Supan, 'Berlin 1810. Bildende Kunst', *Kleist-Jahrbuch*, 1987, pp. 52–75.

36. On Schinkel and Friedrich see Helmut Börsch-Supan, 'Caspar David Friedrich et Carl Friedrich Schinkel', *Revue de l'Art*, 45, 1979, pp. 9–20.

37. *Gotische Klosterruine und Baumgruppen*, Nationalgalerie, West Berlin, NG 8/50, illustrated in the 1976 catalogue, p. 349.

38. The mausoleum was built in the grounds of Charlottenburg Palace in 1812.

39. The possible influence of Schinkel on Friedrich was first suggested by Börsch-Supan, op. cit., 1979, p. 11.

40. For example, *The Chasseur in the Woods*, 1813–14 (BS/J No. 207). For a political interpretation of the *Garden Terrace*, which dates from the same year as the National Gallery *Winter Landscape*, see BS/J, pp. 321ff.

41. BS/J, No. 157. For a general discussion of Friedrich's patriotic themes see BS/J, pp. 28–32; Hans Joachim Kunst, 'Die politischen und gesellschaftlichen Bedingtheiten der Gotikrezeption bei Friedrich und Schinkel' in Berthold Hinz (ed.), *Bürgerliche Revolution und Romantik. Natur und Gesellschaft bei Caspar David Friedrich*, Giessen, 1976, pp. 17–41.

42. See Karl-Ludwig Hoch, 'Caspar David Friedrich, Ernst Moritz Arndt und die sogenannte Demagogenverfolgung', *Pantheon*, XLIV, 1986, pp. 72–5.

43. On the *Winter Landscape* and other works of this period as patriotic themes see Willi Geismeier, *Caspar David Friedrich*, 2nd edn, Leipzig, 1988, pp. 51ff.

44. *Journal des Luxus und der Moden*, 1812, pp. 115–20, cited in BS/J, p. 79.

45. Sigrid Hinz, op. cit., p. 179.

# The Materials and Technique of the *Winter Landscape*

## AVIVA BURNSTOCK

Caspar David Friedrich's success in creating the translucent, misty effects in the National Gallery *Winter Landscape* (Cat. 17) owes as much to his choice of materials and the way he applied them as to the design of the composition. While examination of one painting provides a limited insight into Friedrich's methods, comparison with other works and those of his contemporaries suggests that his style is characterised by the exacting and orderly way in which he planned and executed his paintings.

For Friedrich and his contemporaries painting in Dresden at the beginning of the nineteenth century, the selection of materials was influenced by cost, local availability and the introduction of several new pigments for artists' use. Friedrich was working at a time of change: for example, pigments used in his early works are discarded in later paintings in favour of newly available ones. This gives Friedrich an important place in the history of painting materials. Analysis of the materials and techniques used for the *Winter Landscape* provides useful evidence for the dating and attribution of this painting and of others in Friedrich's oeuvre. The description of the materials and structure of the painting which follows is based on an examination of the *Winter Landscape* using various analytical techniques. A more complete description of the technical examination may be found in the *National Gallery Technical Bulletin*, 13, 1989.

## The Canvas and Priming

The canvas on which the *Winter Landscape* is painted is coated with two layers of off-white priming. These ground layers serve a dual purpose: to prevent subsequent paint layers from being absorbed by the canvas, and to provide a smooth, light-coloured surface on which to draw the composition. Both ground layers consist of a mixture of chalk and lead white with a little umber and ochre. The same combination of materials has been identified in the grounds of three other paintings by Friedrich, and in one painting, *Summer*, 1807 (Neue Pinakothek, Munich), he used a pink ground.

The use of commercially prepared grounds in the first quarter of the nineteenth century is strongly suggested by the results of pigment analysis of the grounds from paintings by seven contemporary artists.[1] Pictures by Klengel, Faber and Friedrich, who all worked in Dresden, have grounds of the same composition as that of the *Winter Landscape*, while the grounds of painters elsewhere in Germany often include other additions. This suggests that primed canvas was used, obtained from a local source.

## Paint Layer Structure and Pigments

The *Winter Landscape* is largely painted using surprisingly few pigments – lead white, red earth and smalt. Particularly interesting is the presence of smalt, a glass-like material which is used on its own in shades that range from pale, translucent grey to deep blue. A few particles of red earth pigment have been added to greyish smalt and white to make the pale mauve of the sky. This limited palette suggests that Friedrich was less interested in colour than in smoothly graduated tones. The simplicity of the composition and flat paint surface is more akin to graphic works on paper than to the painterly quality frequently exploited by artists using an oil medium.

In details such as the clumps of grass, each blade is painted using a fine upturning brushstroke, applied as

a final touch on top of the snow layer. The green and brownish areas of grass contain a more complicated mixture of pigments than is found elsewhere in the painting, including smalt, Naples yellow, bone black, ochre and possibly Prussian blue in varying proportions.

In the first decades of the nineteenth century several new pigments were introduced. Cobalt blue came into use soon after its discovery by Thenard in 1802.[2] Naples yellow, used in some early works, was superseded by chrome yellow, which was in commercial production by 1818. In addition to their particular painterly qualities, pigments were selected because they were inexpensive and easily obtained. Dresden, of course, was a centre for porcelain production and one of the most famous china factories at nearby Meissen was in peak production in 1800. Cobalt ore, mined locally, was processed and used as an underglaze in the manufacture of porcelain.[3] From the same ore, smalt was produced and used in great quantities as a cheap blue pigment for wallpaper and the decorative arts in addition to its use in artists' quality paints.[4]

Friedrich's use of several different grades of smalt for the *Winter Landscape* is unusual since other blue pigments were available at the time. However, the physical characteristics of smalt in oil and the use of stippled brushstrokes, especially in the hills and sky, enhances the transparency and light-scattering quality of the paint surface. This technique effectively recreates the textures of a shimmering, bleak misty landscape, in which hills and sky merge into the space beyond the church. The same effect could not be achieved using either cobalt or Prussian blue in an oil medium, both of which appear comparatively opaque, especially when mixed with white.

Smalt was used as an artists' pigment in Germany much later than in France. It has been found in fourteen paintings by German artists from the first quarter of the nineteenth century, used on its own or mixed with other pigments. Regular use of smalt seems especially common in Dresden, where Friedrich worked; it has been identified in other paintings by Friedrich and in the work of two other Dresden-based artists, Klengel and Faber. At the same time, it was also used by their contemporaries Dillis and Kobell, working in Munich, and by the Norwegian artist Johan Christian Clausen Dahl.

Friedrich exploited the transparent nature of smalt by using the end of the brush to apply the paint in light, small touches so that the brushstrokes barely show. Stippled paint appears in paintings throughout Friedrich's career: for example, in the *Cross and Cathedral in the Mountains* in the Kunstmuseum, Düsseldorf (Cat. 21, ill. p. 39), painted in about 1811, and in the later and much larger *Riesengebirge* (1830–5), now in Berlin.[5] This method of brushwork is used extensively in translucent parts of the painting, especially in the skies and grey-blue areas of the landscape.

## Underdrawing

Perhaps the most interesting feature of Friedrich's painting technique is his detailed rendering of the composition in pencil and pen beneath the paint layer. The extent of the underdrawing is not always visible to the naked eye. However, in infra-red light, which penetrates the paint layer and enhances the contrast of the black lines of the drawing against the white priming on the canvas, the underdrawing can be seen clearly.

Almost without exception, paintings by Friedrich examined in reflected infra-red light reveal beneath the paint layer drawing which is strikingly detailed.[6] The precision with which the underdrawing in the *Winter Landscape* is executed can be seen in Fig. 25. The underdrawing of the church in the Düsseldorf *Cross and Cathedral in the Mountains* (Cat. 21, ill. p. 39) and the figure of Christ on the cross in the Dresden *Cross in the Mountains* (Figs. 6 and 31) are very similar to that found in the *Winter Landscape*.

Two kinds of underdrawing seem to exist beneath the paint. The rocks, figure and parts of the church are drawn using a line of varying thickness which has the fluid quality of ink. In other areas, such as the outlines of the church and crucifix, the line is very fine and appears in some places to have been ruled rather than applied freehand. Reflectography has revealed faint fine lines bisecting the church and gate, which were drawn as a guide to the symmetry of the composition and partly rubbed off before painting. This would imply the use of a medium-free material such as graphite or charcoal, which would smudge less easily than ink or paint when used against a ruler and could be removed easily by brushing. It is also possible that the whole composition was first drawn using fine graphite and parts were subsequently worked over using ink, obscuring the fine lines beneath.

Infra-red photographs of several other paintings by Friedrich show the same combination of fine and ink-like lines in the underdrawing. Infra-red photography of the Dresden *Cross in the Mountains* (Figs. 6 and 31) reveals that the figure of the crucified Christ was first precisely drawn in pen and ink. Ruled

guidelines mark the rays of the setting sun. Other works by Friedrich which have been subjected to infra-red photography, including the Dresden *Mountain Landscape*, painted in the same year as the *Winter Landscape*, show a more fluid style of underdrawing, especially in the foliage.[7]

Interest in the materials and techniques of German nineteenth-century painting has expanded recently with the publication by Althöfer,[8] and technical studies by Plahter of works by Dahl.[9] A study devoted to Friedrich's painting methods is soon to be carried out at the Hochschule für bildende Künste in Dresden. Technical examination will include pigment analysis in addition to infra-red reflectography and X-radiography. This research should lead to a fuller understanding of the evolution of Friedrich's painting methods.

NOTES

1. Spectographic analysis of the grounds of eighteen paintings by Kobell, Dillis, Rebell, Klengel, Hess, Dahl and Faber in the Neue Pinakothek, Munich, has been carried out at the Doerner Institute. Access to the files on these works was kindly given by Dr Andreas Burmester.
2. Cobalt blue was found (without smalt) in two paintings by Friedrich painted after 1820 in the Neue Pinakothek, *Ruined Church in the Woods* and *Riesengebirge Landscape with Rising Mist* (Nos 9872 and 8858). Forty reports examined from the Doerner Institute files on paintings from the second quarter of the nineteenth century showed a trend towards the use of cobalt blue and away from smalt.
3. W. Goder, 'Zur Technik-Geschichte des Meissner Porzellans' in Kunstgewerbemuseum, Köln, *Meissner Porzellan von 1710 bis zur Gegenwart: eine Ausstellung des VEB Staatliche Porzellan-Manufaktur, Meissen, DDR,* exhibition catalogue, 1983, pp. 30-55; see also J. G. Gentele, *Vollständiges Lehrbuch im Potteriefache,* 2nd ed., Leipzig, 1859, pp. 373ff, 455ff.
4. B. Mühlethaler and J. Thissen, 'Smalt', *Studies in Conservation,* 14, 1969, pp. 47–61.
5. *Riesengebirge,* 1830–5, Nationalgalerie, Galerie der Romantik, West Berlin.
6. I. Sandner, 'Besonderheiten der Unterzeichnung auf Gemälden der Romantik' in H. Althöfer (ed.), *Das 19. Jahrhundert und die Restaurierung. Beiträge zur Malerei, Maltechnik und Konservierung,* Munich, 1987, pp. 165–70.
7. Ibid., p. 167.
8. Althöfer, op. cit.
9. L. E. Plahter and U. Plahter, 'J. C. Dahl's Malerier – En Teknisk Undersøkelse' in National Gallery, Oslo, *Johan Christian Clausen Dahl 1788–1857,* exhibition catalogue, 1988, pp. 59–77.

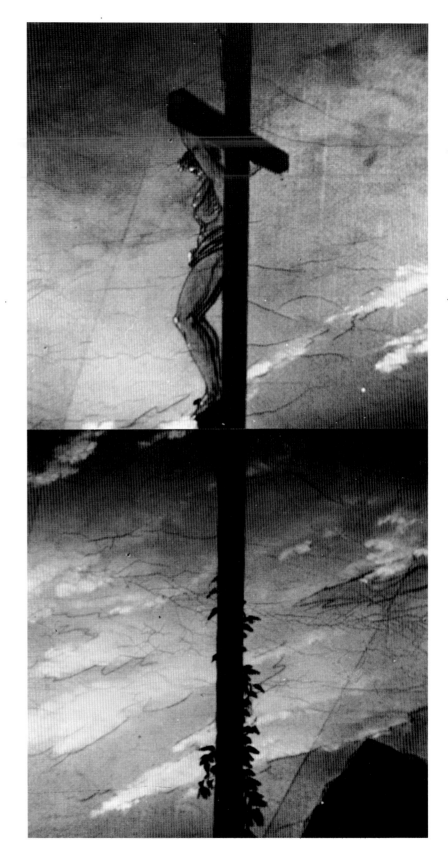

Fig. 31 Infra-red reflectogram of Caspar David Friedrich, *The Cross in the Mountains* (detail). Courtesy of Dr I. Sandner.

# Catalogue

## Compiled by Colin J. Bailey, drawings, and John Leighton, paintings.

ABBREVIATIONS USED IN THE CATALOGUE

BS/J: Helmut Börsch-Supan and Karl Wilhelm Jähnig, *Caspar David Friedrich: Gemälde, Druckgraphik und bildmäßige Zeichnungen*, Munich, 1973 (catalogue number).

Bailey: Colin J. Bailey, *Ashmolean Museum, Oxford. Catalogue of the Collection of Drawings, V. Nineteenth-Century German Drawings*, Oxford, 1987 (catalogue number).

Hinz: Sigrid Hinz, *Caspar David Friedrich als Zeichner. Ein Beitrag zur stilistischen Entwicklung der Zeichnungen und ihrer Bedeutung für die Datierung der Gemälde*, dissertation, Greifswald, 1966 (catalogue number).

GEORG FRIEDRICH KERSTING (1785–1847) *Illus. page 6*

## 1 *Caspar David Friedrich in his Studio (Caspar David Friedrich in seinem Atelier)*

Signed: GK (in monogram) 1811
Oil on canvas, 54 × 42 cm
Kunsthalle, Hamburg, Inv. 1285

Most visitors to Friedrich's studio in Dresden were struck by its unusual simplicity. Kersting's picture (which dates from the same year as the National Gallery *Winter Landscape*) confirms these accounts of his monastic workroom. The artist sits at his easel in a room devoid of the usual appealing clutter. Some drawing instruments and two palettes are the only decorations on the walls. The austere setting and partly shuttered window suggest a private inner world of the imagination, and are consistent with Friedrich's description of painting as a solitary, introspective process.

The painting on the easel has not been identified but it may be a work that is now lost (perhaps the *Mountain Landscape with Waterfall* [BS/J, No. 191]).

Kersting specialised in painting figures in interiors that seem to be an extension of the sitter's personality. After training at the Copenhagen Academy he moved to Dresden in 1808, where he first met Friedrich. The two artists went on a walking tour of the Riesengebirge in 1810, and Kersting is known to have added the figures in some of Friedrich's works (Fig. 9). In 1819 Kersting painted two further portraits of Friedrich at work (Kunsthalle, Mannheim, and Nationalgalerie, West Berlin).

LITERATURE Kunsthalle, Hamburg, *Caspar David Friedrich 1774–1840*, exhibition catalogue, 1974, pp. 312–13.

ADRIAN ZINGG (1734–1816)

## 2 *The Liebethal Valley near Dresden (Der Liebethaler Grund bei Dresden)*

Signed with monogram: A.Z.
Ink and sepia wash, 67.3 × 52.5 cm
Kupferstichkabinett, Dresden, Inv. C 4323

Born in St Gall, Switzerland, Adrian Zingg studied in Zurich, Bern and Paris before moving to Dresden in 1766. By the time Friedrich arrived in the Saxon capital, Zingg had established a reputation for his accomplished landscape

drawings in sepia and in 1803 he was appointed Professor at the Dresden Academy. Friedrich was not a formal pupil of Zingg but he was undoubtedly influenced by the artist's work.

Zingg's drawings were usually topographically accurate and this sheet depicts a valley in the countryside south of Dresden. Although the treatment of the rocks, water and foliage is rather mechanical, the linear rays of sunlight and the contrasts of scale, with massive rocks dwarfing the bathing figures, lend a sense of drama to the scene.

Few of Zingg's works can be dated with any certainty but this drawing may have been executed around 1800.

LITERATURE Kunstmuseum, Bern, *Traum und Wahrheit: Deutsche Romantik aus Museen der Deutschen Demokratischen Republik*, exhibition catalogue, 1985, pp. 70, 358.

CASPAR DAVID FRIEDRICH

## 3 *Cape Arkona at Sunrise (Kap Arkona auf Rügen)*

Sepia over pencil, 66.5 × 99 cm
Kunsthalle, Hamburg, Inv. 1968–107

The chalk cliffs of Cape Arkona, which rise to 177 feet, form a dramatic promontory at the north-eastern tip of Rügen, the Baltic island which inspired so much of the poetry of Gotthard Ludwig Kosegarten. The cape is seen here from the rocky beach at Vitt, on the bay between Arkona and Stubbenkammer. One of the first artists to depict the island's natural beauty was Jacob Philipp Hackert, who executed a series of views of Rügen following his trip to the Baltic in 1762–3. As we know from the autobiography of Gotthilf Heinrich von Schubert, Friedrich was also enchanted by the island, which he visited on numerous occasions between 1801 and 1826.

*Cape Arkona at Sunrise*, which once belonged to his teacher Johann Gottfried Quistorp, is one of Friedrich's largest surviving works in sepia, the medium in which he established his early reputation. The composition is based on a drawing of 22 June 1801, now in Dresden, from the Large Rügen Sketchbook, and the sepia itself was probably produced about 1802. Friedrich referred to a pencil drawing, now in Bremen, for the trees on the left, and for the woman standing with a child near the dry stone wall leading down to the seashore. Under his arm, the child appears to be holding a sketchbook or portfolio.

Cat. 3

Several variants of this composition depicting Cape Arkona under different atmospheric conditions are recorded, but the only other extant sepia is a moonlight scene in the Albertina in Vienna, which contains no staffage figures. In the present version, whose colour is now somewhat faded, Friedrich began by drawing the details in pencil, using a rule for the horizon line and the expanding rays of light, and compasses to describe the circle of the sun. He then applied sepia in thin transparent washes, adding a reddish tinge to the underside of the clouds to the right.

LITERATURE Hinz, No. 282; BS/J, No. 96; Kunsthalle, Hamburg, *Caspar David Friedrich 1774–1840*, exhibition catalogue, 1974, p. 138.

CASPAR DAVID FRIEDRICH

## 4 *Winter*

Sepia over pencil, 19.3 × 27.6 cm
Kunsthalle, Hamburg, Inv. 41118

Around 1803 Friedrich executed a series of four sepia compositions (believed to have been destroyed in the Second World War) in which parallels were drawn between the ages of man, the times of the day, and the seasons of the year. In 1826, and again in 1834, he returned to this idea, extending the series into cycles of seven sepias, incorporating representations of man's spiritual existence before birth and after death. David d'Angers saw five of these in Friedrich's studio during his visit to Dresden in November 1834.

The present version of *Winter*, which probably dates from 1826, is very similar to the original

Cat. 4

composition of 1803, and both appear to have been based on a pencil study in Hamburg (Inv. 41098). In the earlier sepia, however, the old man sat alone by the graveside, whereas here he is accompanied by his wife. There are also slight differences in the details of the architecture, which was inspired by the ruined abbey of Eldena near Greifswald. Through the west window can be seen the setting sun, whose rays cast their final glow over the lifeless winter landscape.

In 1807–8 Friedrich also painted oil versions of *Summer* (BS/J, No. 164) and *Winter* (Fig. 28), though not, it seems, of *Spring* or *Autumn*. In *Summer* he relied almost verbatim on the compositional scheme of the early sepia, but for its pendant *Winter* (destroyed in the Munich Glaspalast fire of 1931) he devised an entirely

new picture that emphasised even more forcefully the pervading sense of death and desolation. In both its mood and its imagery it anticipates the slightly later *Winter Landscape*, in Schwerin (Fig. 24).

LITERATURE Hinz, No. 347; BS/J, No. 432; Kunsthalle, Hamburg, *Caspar David Friedrich 1774–1840*, exhibition catalogue, 1974, p. 276.

CASPAR DAVID FRIEDRICH

## 5 *Landscape after Zingg*

Inscribed by the artist: nach Zing
Pen and black ink, 19.2 × 24 cm
Visitors of the Ashmolean Museum, Oxford

Friedrich's earliest landscape drawings, done while
he was at the Copenhagen Academy, were inspired
by Danish artists such as Jens Juel, Christian
August Lorentzen and Erik Pauelsen. Having
settled in Dresden in 1798, he was eager to
establish contact with the leading landscape
painters there, the most important of whom were
Johann Christian Klengel, Johann Philipp Veith
and Adrian Zingg. These three artists exercised an
important influence on Friedrich's early career as
a landscapist, and several of the drawings he made
shortly after his arrival in the city were copies after
their work.

This drawing after Zingg, whose acquaintance
Friedrich had made by 1800, is among the few
such copies that survive. Stylistically – especially
where the treatment of trees and foliage is
concerned – it is closely related to a drawing in
the Hamburg Kunsthalle dated 26 June 1799

(Inv. 41092), and to others in sketchbooks in East
Berlin (Inv. F II 652 and 653) which Friedrich is
known to have used between 1799 and 1800.
Friedrich's landscape drawings, even those done
from nature, were often executed in pen and ink at
this period, but from 1800 onwards he drew more
and more frequently in graphite, using ink mainly
to reinforce the pencil lines.

LITERATURE Hinz, No. 216; Bailey, No. 30.

CASPAR DAVID FRIEDRICH

## 6 *A Rocky Valley with a Stream*

Dated: den 21t Januar 1802
Pencil, 13.1 × 20.3 cm
Visitors of the Ashmolean Museum, Oxford

Friedrich began drawing from nature around 1797
while he was still a student in Copenhagen, and
remained an assiduous draughtsman throughout
his life. Most of his early drawings outdoors were
either studies of single motifs, such as trees and
plants, or simple landscape compositions. At first
he drew mainly in pen and ink, occasionally
augmented by monochrome washes, but by 1800

Cat. 5

59

he had largely abandoned ink in favour of pencil, which remained his favourite sketching medium. With this he rapidly became adept at producing an astonishing range of graphic effects, and an intimation of his later skill is already evident here.

Though he was reluctant to go as far afield as Switzerland or Italy, Friedrich travelled extensively within Germany, making frequent visits to Rügen and his Baltic homeland and going on sketching tours to the Riesengebirge and the Harz. This drawing probably records a scene in the southern Sächsische Schweiz (Saxon Switzerland), a region south-east of Dresden near the modern border with Czechoslovakia, where rocky valleys of this kind are common. In marked contrast to his many botanical studies, which were invariably drawn with minute attention to detail, Friedrich's landscape sketches were often executed in this rather cursory fashion. What is especially interesting here is the way in which he achieved the effect of aerial perspective by subtly modifying his pressure on the pencil, and by using the blunted tip of a soft pencil for the boldly drawn bush and cluster of flowers in the foreground, while reserving a harder, sharper pencil for the less distinct forms in the middle distance and the broken contours of the far hill.

LITERATURE Bailey, No. 31.

CASPAR DAVID FRIEDRICH

## 7 *Landscape in Bohemia*

Dated: den 6t May 1803
Brown ink and sepia, 11.4 × 18 cm
Visitors of the Ashmolean Museum, Oxford

This sepia and a slightly later version of the same subject in Dresden (Inv. C 1927–35) provide indisputable evidence that Friedrich undertook his first sketching tour of Bohemia as early as 1803, and not, as was previously believed, in 1807. Both drawings depict the distant silhouette of Mount Jeschken (Jested), with the cross on its summit that was erected in 1737, viewed from the south-east near Reichenberg (present-day Liberec). The Dresden composition differs in having a bridge and a wayside chapel in the foreground in place of the ploughed field.

Although at first sight this drawing appears to be perfectly rectangular, only careful restoration disguises the fact that, like *Landscape with an*

*Obelisk* (Cat. 8), it has been cut diagonally at each corner. Minor excisions of this kind are common to several other landscape compositions of similar size and date in Dresden, Hamburg, Kiel, Leipzig, and elsewhere, and it seems likely that they may have been worked up from drawings contained in a sketchbook that Friedrich first used during his walking tour of Rügen in May 1802, and afterwards took with him to Saxony and Bohemia.

Compositionally, the drawing is closely related to two other sepias: *Landscape at Sunrise*, of around 1804–5, now in the Goethe Nationalmuseum in Weimar, and what is thought to be a contemporary replica in the König Collection in Fachsenfeld. Though the landscape backgrounds and minor details in the foregrounds differ, all three are virtually identical in size and it is possible that the Oxford drawing served as the prototype for the later versions.

LITERATURE Eva Reitharová and Werner Sumowski, 'Beiträge zu Caspar David Friedrich', *Pantheon*, XXXV, 1977, pp. 41–2; Bailey, No. 32.

CASPAR DAVID FRIEDRICH

## 8 *Landscape with an Obelisk*

Dated: den 25t May 1803
Brown ink and sepia, 12.9 × 20.2 cm
Visitors of the Ashmolean Museum, Oxford

This sepia almost certainly comes from the same sketchbook as the Oxford *Landscape in Bohemia* (Cat. 7). At the turn of the century, works based on uncomplicated topographical views of this kind constituted Friedrich's primary source of income. The subject has still to be identified but the scene is probably somewhere in Saxony and may depict the little town of Stolpen. The obelisk in the foreground is almost certainly a milestone of the type used by the Saxon postal service. A similar milestone, where the post horn is clearly visible, features prominently in a drawing from the Mannheim Sketchbook, now in the Staatliche Graphische Sammlung in Munich (Inv. 1955:6). The juxtaposition of the milestone and the wayside cross in the middle distance may indicate that Friedrich intended this to be construed as an allegory of the journey through life.

*Landscape with an Obelisk* and *Landscape in Bohemia* are characteristic examples of the sepia technique that Friedrich developed for his small-

Cat. 8

scale compositions. After the details had been drawn in brown ink using a fine pen and the tip of a thin hair brush, he then proceeded to lay in the washes, which ranged from whitish-brown to bistre. Varying strengths of colour were produced by adjusting the proportions of pigment and water and by the occasional admixture of gum arabic to thicken the medium.

LITERATURE Bailey, No. 33.

CASPAR DAVID FRIEDRICH

## 9 *A Megalithic Tomb*

Inscribed and dated: den 16t Juli 1806 / aus Rügen
Pencil, 26 × 36 cm
Visitors of the Ashmolean Museum, Oxford

This drawing was made during Friedrich's sketching tour of Rügen in 1806, which lasted from 29 June to 20 July. It records a prehistoric burial mound just outside Dwasieden, a small

fishing village on the east coast of the island, two miles south-west of Sassnitz. Dolmens, cromlechs and barrows abound in the Baltic region of northern Germany and Friedrich noted several in his sketchbooks. Many were subsequently incorporated in his finished paintings, either as symbols of a pagan past or simply for their elegiacal associations. One of his large early sepias depicted a dolmen by the sea (BS/J, No. 147); *Dolmen in Autumn* (BS/J, No. 271) was painted around 1820 as his reception piece for the Dresden Academy; and in the sepia compositions to which he returned towards the end of his life dolmens feature with graveyard subjects as poignant symbols of death.

Friedrich used this drawing, which is squared in pencil for transfer, as the model for the prehistoric barrow in the foreground of his lost *Evening Landscape* (BS/J, No. 222), a picture normally dated to around 1817. This in turn was the inspiration for paintings by Carl Gustav Carus of

the barrow near Nobbin, of which one version is in the Thorvaldsens Museum in Copenhagen and another in the National Gallery in Oslo.

LITERATURE Hinz, No. 422; Bailey, No. 34.

CASPAR DAVID FRIEDRICH

## 10 *Study of an Oak Tree and a Church*

Inscribed and dated: den 15t Juni 1809 / Breesen
Pencil, 14.3 × 32.7 cm
Visitors of the Ashmolean Museum, Oxford

This drawing was executed during Friedrich's stay from May till June 1809 in Breesen near Neubrandenburg, east of Frankfurt an der Oder, where his sister Catharina Dorothea had settled following her marriage in 1791 to a local pastor, August Jakob Sponholz. Friedrich made dozens of drawings of trees in the countryside around Breesen, including this characteristic study of an old oak with a small church just visible to the right. Here twigs, leaves and leaf clusters are minutely described, and a mass of short, thick, densely applied pencil strokes perfectly conveys the coarse texture of the bark on the trunk and lower branches. The same tree, viewed from the opposite direction, appears in a drawing made eight days earlier, now in the National Gallery in Oslo (Inv. B 16018).

Among the deciduous trees, it is the oak that occurs most frequently in Friedrich's sketchbooks and which is most often depicted in his paintings. In *Abbey among Oak Trees* (Fig. 8), the leafless trees are intended simply to emphasise the barrenness of winter, but Friedrich sometimes used the oak in a more specific way to signify pagan worship, which is clearly how it is meant to be understood in the Dresden *Dolmen in the Snow* (BS/J, No. 162) and the Louvre *Tree with Ravens* (BS/J, No. 289).

LITERATURE Bailey, No. 35.

CASPAR DAVID FRIEDRICH

## 11 *Studies of Trees (Baumstudien)*

Inscribed and dated: Neubrandenburg /
    den 25t Aprill 1809 / Eiche *and* den 26t Aprill 1809
Pencil, 31.7 × 25.8 cm
Kupferstichkabinett, Dresden, Inv. C 1937–417

These studies, from a sketchbook whose pages are

now dispersed, were drawn during Friedrich's visit in the Spring of 1809 to Neubrandenburg, the town where both his parents were born, and which he regarded as his second home. He arrived there in April and seems to have remained in the area until July, interrupting his stay to visit Greifswald and Gützkow and his sister in nearby Breesen. During this period he covered the pages of his sketchbooks with dozens of studies of trees, many of which he later incorporated in his pictures. Both of the studies on this sheet were used for the trees in the Schwerin *Winter Landscape* (Fig. 24). The roots and bottom branch of the tree in the foreground of the painting were copied almost exactly from the lower drawing, though Friedrich changed its upper branches. He made more significant alterations to the oak tree at the top of the sheet, inclining it more to the left and considerably extending one of the branches in order to balance his composition.

Many of the motifs in Friedrich's pictures can be traced in this way to drawings on which he inscribed the date, and when there is no other reliable documentary evidence for establishing the exact chronology of his paintings (which he never dated), such drawings are extremely useful in providing a secure *terminus post quem*.

LITERATURE Hinz, No. 508; Kunsthalle, Hamburg, *Caspar David Friedrich 1774–1840*, exhibition catalogue, 1974, p. 161.

CASPAR DAVID FRIEDRICH

## 12 *Study of Fir Trees (Tannengruppe)*

Pencil, 20.2 × 15.8 cm
Kupferstichkabinett, Dresden, Inv. C 1937–425

This study was used for the two fir trees in the centre of Friedrich's *Mountain Landscape*, in Dresden (Cat. 15). Four other studies, in the Oslo Sketchbook of 1807, all produced in April or May of that year, provided him with details for the fir trees on the left of the picture and the young beech tree on the right. Stylistically, the Dresden drawing is similar to those in Oslo and may have been produced about the same time. It must have been in existence by June 1811 when the artist Gustav Heinrich Naeke visited Friedrich's studio and found the *Mountain Landscape* in progress.

Although Friedrich occasionally drew large tracts of woodland, his usual custom, especially in the years between 1806 and 1809, was to draw

trees singly or in very small groups. When painting clusters of trees, as in the Dresden *Mountain Landscape*, he combined several individual studies for his underdrawings, in what was evidently a considered and painstaking procedure.

LITERATURE Hinz, No. 593.

CASPAR DAVID FRIEDRICH *Illus. page 38*

## 13 *Seashore with Fisherman (Meeresstrand mit Fischer)*

Oil on canvas, 34.5 × 51 cm
Österreichische Galerie, Vienna, Inv. NG 98

This picture and its companion piece, *Mist* (Cat. 14), are usually dated to 1807 and are therefore among Friedrich's first paintings in oil. Friedrich often produced pictures which were intended to be read as pendants or in series, a practice that he carried over from his sepia drawings. With some of these pairs (for example the London and Schwerin Winter Landscapes) the relationship is quite clear, but here the meaning of the two paintings is not obvious. In *Seashore with Fisherman* the focus is on the foreground. A fisherman carrying poles and boat hooks stands by the shore next to some nets and a rack for drying hay. The clarity of the first picture is countered by the mystery and uncertainty of the companion piece,

where a rowing boat delivers passengers to a ship lying at anchor. Börsch-Supan interprets the relationship between the two works as the contrast between the earthly and the spiritual, and suggests that the second picture should be read as an allegory of death. However, Friedrich's symbolism is often elusive and ambiguous and the different moods and effects of the two paintings merely offer clues to their interpretation. They are among the most evocative of the artist's early works and are perhaps best described as poetic landscapes rather than specific allegories.

Friedrich's career as a draughtsman was already well established when he began to paint in oils. It is unlikely that he had any extensive training in the techniques of oil painting and the thin, precise application of paint in these early works is a method that Friedrich adapted from his sepia drawings (see for example Cat. 3).

LITERATURE BS/J, No. 158; Kunsthalle, Hamburg, *Caspar David Friedrich 1774–1840*, exhibition catalogue, 1974, p. 153; Albertinum, Dresden, *Caspar David Friedrich und sein Kreis*, exhibition catalogue, 1974, p. 102.

CASPAR DAVID FRIEDRICH *Illus. page 38*

## 14 *Mist (Nebel)*

Oil on canvas, 34.5 × 52 cm
Österreichische Galerie, Vienna, Inv. NG 97

See entry for Cat. 13.

LITERATURE BS/J, No. 159; Kunsthalle, Hamburg, *Caspar David Friedrich 1774–1840*, exhibition catalogue, 1974, pp. 154–5; Albertinum, Dresden, *Caspar David Friedrich und sein Kreis*, exhibition catalogue, 1974, p. 103; Musée de l'Orangerie, Paris, *La peinture allemande a l'époque du Romantisme*, exhibition catalogue, 1976, p. 43.

CASPAR DAVID FRIEDRICH

## 15 *Mountain Landscape (Felspartie im Harz)*

Oil on canvas, 32 × 45 cm
Gemäldegalerie Neue Meister, Dresden, Inv. 3680

Although this picture is traditionally thought to depict a landscape in the Harz mountains it was probably painted before Friedrich's visit to this region in the summer of 1811, since it was noticed by Gustav Heinrich Naeke in the artist's studio in June of that year. The limited range of colour and

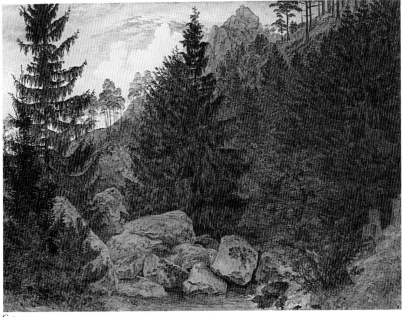

Cat. 15

the thinly applied paint are typical of Friedrich's early work. A number of earlier studies after nature were used as the basis of the composition (including Cat. 12), and an infra-red photograph reveals an elaborate underdrawing, probably in pen and ink.

The dramatic landscape scenery, with boulders, fir trees and a mountain stream, is reminiscent of works by seventeenth-century Dutch artists like Allart van Everdingen, and the composition may have been inspired by Jacob van Ruisdael's *Waterfall with a Castle on a Mountain*, which Friedrich could have seen in the Dresden Picture Gallery.

LITERATURE BS/J, No. 195; Albertinum, Dresden, *Caspar David Friedrich und sein Kreis*, exhibition catalogue, 1974, pp. 112, 121.

CASPAR DAVID FRIEDRICH    *Illus. page 46*

## 16 Landscape with Oak Trees and a Hunter (Landschaft mit Eichen und Jäger)

Oil on canvas, 32 × 44.5 cm
Museum Stiftung Oskar Reinhart, Winterthur

This picture must have been completed by June 1811, when it was seen in Friedrich's studio by Gustav Heinrich Naeke. It was exhibited in Weimar in 1812 and by 1813 had been acquired by Dr Ludwig Puttrich, who was also the first owner of the National Gallery *Winter Landscape*.

The Winterthur painting has the same dimensions as the Winter Landscapes in London and Schwerin and, since they must all date from the same period, Börsch-Supan has suggested that these three works may have been conceived as a series. He proposes that in a cycle of the seasons the *Landscape with Oak Trees and a Hunter* would precede the Schwerin *Winter Landscape* and should be interpreted as an allegory of the fate of man in a world without religion. For Börsch-Supan, the tiny figure of the hunter, barely visible in the foreground vegetation, is subject to the laws of nature, and he interprets the oak trees as symbols of a pagan attitude to life.

When the Winterthur painting was in Puttrich's collection it was indeed described as an 'autumn' landscape, but it seems doubtful that the painting was intended to be thematically linked to the Winter Landscapes. Whereas the symbolism of the London and Schwerin paintings is readily apparent

and the two works are obviously related, it is more difficult to interpret the imagery of the *Landscape with Oak Trees and a Hunter* in terms of religious symbolism. Furthermore, when Naeke saw the picture in Friedrich's studio in 1811 he described it as a pendant to the *Mountain Landscape* (Cat. 15), a painting which seems to be a more appropriate companion piece. Although the *Landscape with Oak Trees and a Hunter* and the *Mountain Landscape* depict quite different types of scenery, they both present nature as untamed and inhospitable, with foregrounds that look inaccessible to the spectator. Both pictures appear to be directly inspired by Dutch landscape painting – the composition of the Winterthur painting is particularly reminiscent of Jacob van Ruisdael. Friedrich would have been familiar with hunting scenes by this artist (for example, *The Hunt*, in the Dresden Picture Gallery), which are the most likely source for the imagery of this work.

LITERATURE BS/J, No. 195; Helmut Börsch-Supan, *Caspar David Friedrich*, Munich, 1973, p. 92; Stiftung Oskar Reinhart, Winterthur, *Deutsche und österreichische Maler des 19. Jahrhunderts*, catalogue by Peter Vignau-Wilberg, Zurich, 1981, pp. 88–9.

CASPAR DAVID FRIEDRICH

## 17 Winter Landscape

Oil on canvas, 32.5 × 45 cm
National Gallery, London, No. 6517

Acquired at Christie's sale, Monaco, 7 December 1987, Lot 107. See essay in the main text.

LITERATURE National Gallery Annual Report, January 1988 – March 1989, pp. 6–9; John Leighton, Anthony Reeve, Aviva Burnstock, 'The *Winter Landscape* by Caspar David Friedrich', *National Gallery Technical Bulletin*, 13, 1989, pp. 44–51.

ASCRIBED TO CASPAR DAVID FRIEDRICH

## 18 Winter Landscape (Winterlandschaft mit Kirche)

Inscribed on a piece of wood inserted into the back of the stretcher: Friederich Dresden den 20. Juli 1811
Oil on canvas, 33 × 45 cm
Museum für Kunst und Kulturgeschichte der Stadt, Dortmund, Inv. C 4737

This picture was first published in 1941, and until the recent discovery of the National Gallery *Winter Landscape* was accepted as the composition that

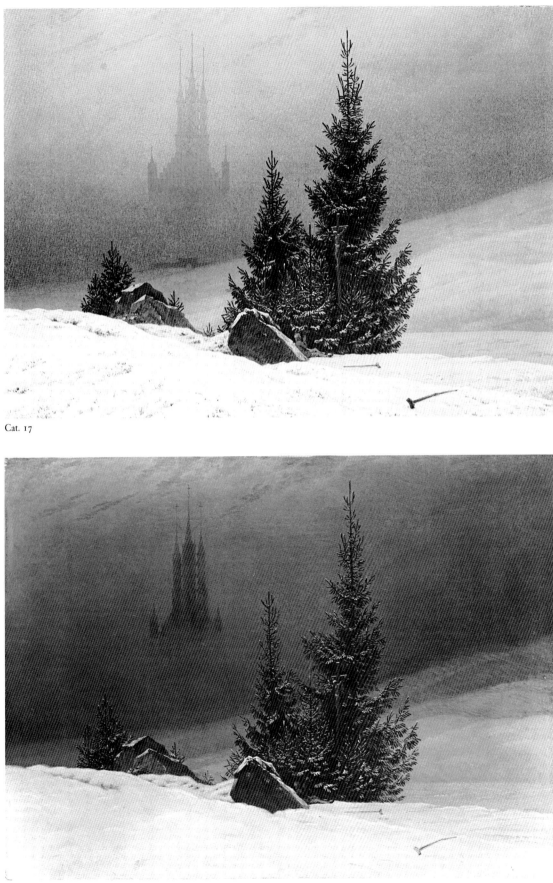

Cat. 17

Cat. 18

Friedrich is known to have painted in 1811. Now the status of the Dortmund painting is unclear. It could be a replica by Friedrich himself or a copy by a pupil or follower (see essay in main text).

Several important details that appear in the National Gallery painting are missing from the Dortmund picture, including the gate in front of the church and the blades of grass in the foreground. Furthermore, in comparison to other works by Friedrich of around 1811 the Dortmund version is quite freely painted and lacks the care and precision that is characteristic of the artist's early style. Friedrich's handling of paint did become broader in the later 1820s, partly because of an increasing tendency towards naturalism in his work and partly as a result of a series of illnesses. It is conceivable that the Dortmund painting is a later reprise by the artist himself. However, Börsch-Supan, who earlier included the Dortmund painting in his catalogue raisonné, now believes that it is a copy. If this is correct, then it seems most likely that it was painted while the

London picture was still in Friedrich's studio, perhaps as the inscription suggests, in 1811.

LITERATURE BS/J, No. 194; Kunsthalle, Hamburg, *Caspar David Friedrich 1774–1840*, exhibition catalogue, 1974, p. 185; Albertinum, Dresden, *Caspar David Friedrich und sein Kreis*, exhibition catalogue, 1974, pp. 111–12; Musée de l'Orangerie, Paris, *La peinture allemande a l'époque du Romantisme*, exhibition catalogue, 1976, p. 52.

KARL WILHELM LIEBER (1791–1861)

## 19 *Winter Landscape* (after Friedrich)

Inscribed: Carl Lieber fec.
Pencil and watercolour, 40.9 × 50 cm
Nationale Forschungs– und Gedenkstätten der Klassischen deutschen Literatur in Weimar

Lieber began his artistic career as a student at the Free Drawing Academy in Weimar under Johann Heinrich Meyer. On the advice of Goethe, he travelled to Dresden in 1812 to study under Georg Friedrich Kersting and Caspar David Friedrich.

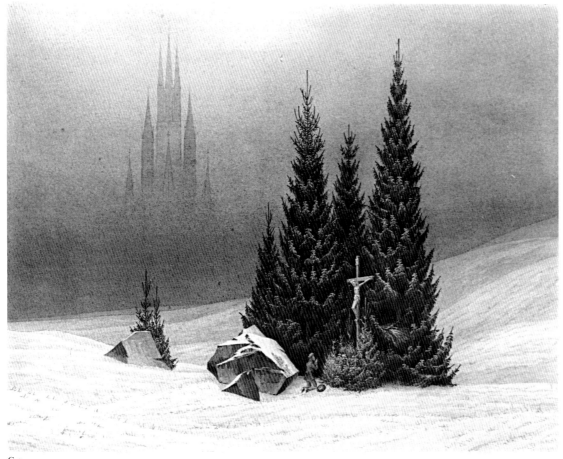

Cat. 19

He produced this copy of the *Winter Landscape* (Cat. 17) in the same year, presumably when the painting was still in Friedrich's studio. In a letter to Meyer, Goethe recorded that this copy was the cause of a quarrel between the master and his student. Friedrich was apparently upset by Lieber's misunderstanding of his composition and the young artist was banished from his studio.

Only a few of Lieber's works have survived and he seems to have been an artist of mediocre talent. Nevertheless, a drawing after Ruisdael's *Landscape with a Waterfall and Castle* demonstrates that he was at least capable of producing a faithful copy. His copy of Friedrich's *Winter Landscape*, however, is a stylised pastiche which displays little sympathy for the visionary content of the original. Lieber has simplified the forms of the rocks and trees and has replaced the cripple with a kneeling figure. It is not difficult to imagine why Friedrich should have been upset by a copy that misrepresents his powerful evocation of nature and alters the symbolic content of his work.

LITERATURE Otto Kletzl, 'Ideale Landschaften des Zeichners Goethe', *Jahrbuch des Freien Deutschen Hochstiftes zu Frankfurt*, 1932–3, pp. 314–24; Kurt Karl Eberlein, 'C.D. Friedrich, Lieber und Goethe. Mit einem wiedergefundenen Winterbild Friedrichs', *Kunst-Rundschau*, January 1941, 1, pp. 5–7.

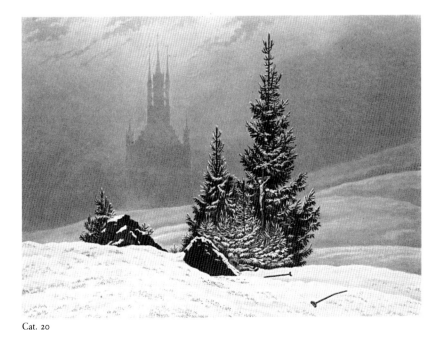

Cat. 20

JOHANN JACOB WAGNER (1766–1834)

## 20 *Winter Landscape* (after Friedrich)

Aquatint, 21.4 × 29.3 cm
Staatliche Museen Preußischer Kulturbesitz,
  Kupferstichkabinett, West Berlin

The date of this aquatint after Friedrich's *Winter Landscape* is not known but it was probably produced while the painting was in the collection of Dr Ludwig Puttrich in Leipzig. The print was exhibited in Dresden and Weimar in 1820 and in Leipzig in 1828.

Unlike the watercolour by Karl Wilhelm Lieber (Cat. 19), Wagner's print is a fairly faithful copy and seems to have been based on the National Gallery picture (Cat. 17) rather than the painting in Dortmund (Cat. 18). Wagner includes the grass pushing through the melting snow in the foreground and his church corresponds more closely to the London picture. However, he has omitted the little gate in front of the church, a detail which is also absent in the Dortmund version.

LITERATURE BS/J, p. 319; Ludwig Volkmann, *Die Jugendfreunde des 'Alten Mannes'. Johann Wilhelm und Friederike Tugendreich Volkmann, nach Briefen und Tagebüchern*, Leipzig, 1925, p. 234; Paul Ortwin Rave, 'Zwei Winterlandschaften C.D. Friedrichs', *Zeitschrift für Kunstwissenschaft*, V, 1951, pp. 229–34; K. W. Jähnig, 'Zwei Briefe Caspar David Friedrichs', *Kunst und Künstler*, XXVI, 1928, pp. 103–9.

CASPAR DAVID FRIEDRICH   *Illus. page 39*

## 21 *Cross and Cathedral in the Mountains (Das Kreuz im Gebirge)*

Oil on canvas, 44.5 × 37.4 cm
Kunstmuseum, Düsseldorf, Inv. 3

The overt religious symbolism in this painting relates to the earlier *Cross in the Mountains* (Fig. 6) and the National Gallery *Winter Landscape* (Cat. 17). Friedrich reworks one of his favoured compositional arrangements, contrasting the bleak, inhospitable foreground with the triumphant façade of the cathedral rising out of the mist in the distance. A barren terrestrial world is set against an awe-inspiring celestial vision and, at the centre of the painting, the crucifix mediates between these two realms, an unequivocal sign that salvation can only be attained through Christ. Friedrich's explanation of the *Cross in the Mountains* (see p. 15) allows us to interpret the

rocks and the fir trees as symbols of faith. The sun penetrating the mist, the melting snow and the water which flows from the base of the cross reinforce the message of hope and renewal.

The date of the Düsseldorf picture is not known but in technique it is closely related to paintings of around 1811–12, including the *Mountain Landscape* (Cat. 15). The large fir tree on the left seems to be based on a drawing after nature which is dated 1812 (Hinz, No. 598), and this may be regarded as a *terminus post quem* for the painting. Although the cathedral is an imaginary structure it is apparently based on a lost drawing of the Marienkirche in Neubrandenburg, a church which appears in several paintings by Friedrich. The details of the pinnacles and the geometrical tracery of the windows correspond closely to the architecture of the church in the *Winter Landscape* (Cat. 17).

LITERATURE BS/J, No. 201; Kunsthalle, Hamburg, *Caspar David Friedrich 1774–1840*, exhibition catalogue, 1974, pp. 188–9; Albertinum, Dresden, *Caspar David Friedrich und sein Kreis*, exhibition catalogue, 1974, pp. 123–4; Kunstmuseum Düsseldorf, *Die Gemälde des 19. Jahrhunderts*, catalogue by Rolf Andree, 1981, pp. 84–7.

CASPAR DAVID FRIEDRICH *Illus. page 42*

## 22 *Cross on the Baltic (Das Kreuz an der Ostsee)*

Oil on canvas, 45 × 32 cm
Verwaltung der Staatlichen Schlösser und Gärten, Schloß Charlottenburg, West Berlin, Inv. G.k.I 30203

With its underlying message of salvation through the Christian faith, this painting develops the theme of the *Cross in the Mountains* (Fig. 6) and the *Winter Landscape* (Cat. 17). The cross is erected on the rock of faith while the anchor may be read as a traditional symbol of hope. Rather less obvious is the symbolism of the moon (representing the Saviour) and the boats returning to shore (images of the transience of life).

Although this is one of Friedrich's most emblematic compositions, the artist himself stressed the ambiguity of his imagery in a letter of May 1815 to his artist friend Luise Seidler: 'The picture destined for your friend is already sketched out but there will be no church in it, nor a tree, nor a plant, nor a blade of grass. Raised up high on the barren, rocky seashore is a cross: to those who see it a consolation; to those who fail to see

it, merely a cross.' On the second page of his letter Friedrich added a small sketch of the composition with the word 'moonlight' written beneath it (Fig. 26).

The picture in Berlin is one of four versions of this composition: the others are in the Wallraf-Richartz-Museum, Cologne (Cat. 23); the Schäfer Collection, Schweinfurt; and a private collection in Hamburg. Before the recent discovery of the Berlin painting, at least two of the other versions were accepted as works by Friedrich. However, when it was first published in 1973, Helmut Börsch-Supan argued that the Berlin painting was the only autograph version of the composition and suggested that the other pictures are copies.

Börsch-Supan observed that the sketch in Friedrich's letter shows some poles and a boat hook wedged behind a rock. This arrangement appears only in the Berlin painting, being replaced in the other pictures by tautened ropes stretching out of the composition, which might suggest that they are the work of a copyist who misunderstood the artist's original intentions. In his letter, Friedrich states that the picture is destined for one of Luise Seidler's female friends, and Börsch-Supan proposed that this could be the painter Therese aus dem Winckel, who was well known for her copies of old master and contemporary paintings. Therese aus dem Winckel was certainly familiar with Friedrich's work and if she was the first owner of the *Cross on the Baltic* then it seems reasonable to suggest that she may have produced copies of it.

Against this thesis, the compilers of the catalogue for the 1974 Friedrich exhibition in Hamburg noted that the thumbnail sketch in Friedrich's letter is not necessarily a reliable record of the appearance of the finished picture. There are several details in all the paintings, including the ships and the wooden supports for the cross, which are not shown in this preliminary drawing.

Nevertheless, Börsch-Supan's argument is supported by a stylistic analysis of the various versions. The Berlin picture is painted in the thin, graphic style of Friedrich's early works. The Cologne picture is more freely painted, particularly in the sky, and the contours are softer and less precise than in the Berlin version. But it is an accomplished painting and the possibility that it is by Friedrich cannot be ruled out. It is worth noting that an infra-red photograph of the

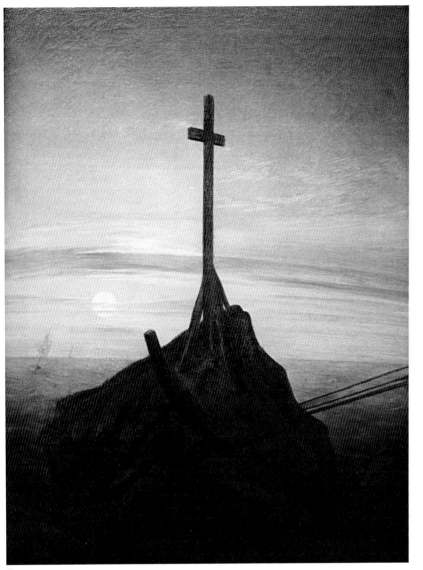

Cat. 23

Cologne painting indicates what may be an area of damage where the ropes meet the right-hand edge of the picture. If this part of the painting has been repaired and retouched, then it is possible that in its original state the Cologne painting showed the same arrangement of poles and hooks that appears in the Berlin version.

LITERATURE BS/J, No. 215; Helmut Börsch-Supan, *Die Gemälde C. D. Friedrichs im Schinkel-Pavillon*, Berlin, 1973, pp. 25–8; Kunsthalle, Hamburg, *Caspar David Friedrich 1774–1840*, exhibition catalogue, 1974, pp. 200–1; Helmut Börsch-Supan, 'Die Erwerbungstätigkeit der Staatlichen Schlösser und Gärten in Berlin seit 1945' in *Festschrift für Margarete Küfer*, Berlin, pp. 48ff; Werner Sumowski, *Caspar David Friedrich-Studien*, Wiesbaden, 1970, pp. 179).

ASCRIBED TO CASPAR DAVID FRIEDRICH

## 23 *Cross on the Baltic (Das Kreuz an der Ostsee)*

Oil on canvas, 46 × 33.5 cm
Wallraf-Richartz-Museum, Cologne, Inv. WRM 2483

See entry for Cat. 22.

LITERATURE Anna Maria Kesting, 'Ein Brief Caspar David Friedrichs an Luise Seidler', *Wallraf-Richartz-Jahrbuch*, XXXI, 1969, pp. 255ff; BS/J, No. XXV (as a copy, perhaps by Therese aus dem Winckel); Kunsthalle, Hamburg, *Caspar David Friedrich 1774–1840*, exhibition catalogue, 1974, pp. 200–1; Linda Siegel, *Caspar David Friedrich and the Age of German Romanticism*, Boston, 1978, p. 165.

CASPAR DAVID FRIEDRICH  *Illus. page 43*

## 24 *Two Men Contemplating the Moon (Zwei Männer in Betrachtung des Mondes)*

Oil on canvas, 35 × 44 cm
Gemäldegalerie Neue Meister, Dresden, Inv. 2194

The Dresden Picture Gallery acquired this painting in 1840 from the artist, Johan Christian Dahl. In a letter to the Gallery, Dahl noted that the picture dated from 1819 and identified the two figures in the foreground as Friedrich's brother-in-law, Christian Wilhelm Bommer, and his favourite pupil, August Heinrich. A different identification was provided in 1859 by Wilhelm Wegener, who recorded that the man on the right was Friedrich himself. This is more convincing since Friedrich often included his own likeness in his paintings and the younger man seems to be leaning on the older figure, as if to suggest the relationship between a pupil and his master.

This painting of two men, locked in silent communion with nature, is one of Friedrich's most poetic images. The abrupt contrast between the detailed foreground and the infinite distance that lies beyond enhances the mood of meditation and mystery. The figures are wearing the traditional German dress that had been revived during the War of Liberation (1813–15) and which had since taken on subversive associations as the costume of the democratic movement. In a period of mounting repression and persecution, Friedrich is known to have sympathised with political reform. He told a visitor to his studio in 1820 that the two men in his picture were engaged in 'demagogic

machinations', an ironic reference to the *Demagogenverfolgung*, the suppression of the liberal and democratic movement. However, it seems unlikely that the painting is intended to be read as a political statement, with beleaguered German patriots contemplating the fate of their nation. By contrast, Helmut Börsch-Supan interprets the painting as a religious allegory, with the moon (a symbol of Christ) illuminating the stony path of life.

Dahl recorded that Friedrich was commissioned to produce several replicas of this composition. There are two paintings in private collections (Cat. 25) which could be repetitions painted by the artist, although the authorship of these works has been disputed. A later variant, with a man and woman in the foreground, is in the Nationalgalerie in West Berlin.

LITERATURE BS/J, No. 261; Kunsthalle, Hamburg, *Caspar David Friedrich 1774–1840*, exhibition catalogue, 1974, pp. 226–7; Albertinum, Dresden, *Caspar David Friedrich und sein Kreis*, exhibition catalogue, 1974, p. 131.

Cat. 25

ASCRIBED TO CASPAR DAVID FRIEDRICH

## 25 *Two Men Contemplating the Moon (Zwei Männer in Betrachtung des Mondes)*

Oil on canvas, 34 × 43 cm
Private collection, Solothurn

This is a version of Friedrich's painting of 1819, now in the Gemäldegalerie Neue Meister in Dresden (Cat. 24). Johan Christian Dahl (who was the first owner of the Dresden painting) recorded that Friedrich was commissioned to produce several replicas of *Two Men Contemplating the Moon* and it is possible that this picture is one of these. Werner Sumowski published it as a replica by Friedrich, but Börsch-Supan lists it as a copy by a follower from the circle of Dahl or Friedrich, suggesting Julius von Leypold as the copyist. (Leypold was a pupil of Dahl at the Dresden Academy in the 1820s and his work was greatly influenced by Friedrich during this period.)

There are some minor variations between this picture and the prime version in Dresden. In particular, the branches and twigs of the central oak tree have been simplified and the foreground is also slightly less detailed. The two paintings also differ in style. The replica has a harsher and less

subtle colour scheme, and the contours are stronger and more clearly defined than in the Dresden version. Nevertheless, it seems appropriate to describe this picture as a replica or copy rather than a variant of the Dresden painting, and if it is by Friedrich then it must be a fairly late work, perhaps from the 1830s. However, a certain hesitant quality in the drawing and the comparative weakness of some passages in the foreground (for example the tree stump on the left) seem to support Börsch-Supan's view that this is an early copy by a pupil or follower.

LITERATURE Werner Sumowski, *Caspar David Friedrich–Studien*, Wiesbaden, 1970, p. 179; BS/J, No. XLIII (as a copy); Museum of Modern Art, Hyogo, Japan, *The Rediscovery of Nature. An Anthology of 19th-Century Landscape Painting in the West*, exhibition catalogue, 1983.

# Bibliography

Compiled by Colin J. Bailey. A complete bibliography up to 1972 is contained in Helmut Börsch-Supan and Karl Wilhelm Jähnig, *Caspar David Friedrich: Gemälde, Druckgraphik und bildmäßige Zeichnungen*, Munich, 1973. Listed here are the most important publications that have appeared since that date.

BAILEY, C. J., 'Six Drawings by Caspar David Friedrich in the Ashmolean Museum', *Master Drawings*, XIII, 3, 1975, pp. 274–80.
'Another Drawing by Friedrich in the Ashmolean Museum', *Master Drawings*, XXI, 2, 1983, pp. 172–4.
'Religious Symbolism in Caspar David Friedrich', *Bulletin of the John Rylands University Library of Manchester*, LXXI, 3, 1989, pp. 5–20.
BAILLY, J.-C. and MONORY, J., *Hommage à Caspar David Friedrich*, Paris, 1977.
BARTETZKO, D., 'Reisebilder: Überlegungen zu zwei Gemälden von C. D. Friedrich und C. G. Carus', *Kritische Berichte*, VII, 1, 1979, pp. 5–19.
BAUMER, D., 'Caspar David Friedrich: zum 200. Geburtstag', *Kunst und das schöne Heim*, LXXXVI, 9, 1974, pp. 536–9.
BECKER, I., *Caspar David Friedrich: Leben und Werk*, Stuttgart and Zurich, 1983.
BÖRSCH-SUPAN, H., *Caspar David Friedrich*, London, 4th revised edn, 1987.
*L'opera completa di Friedrich*, Milan, 1976.
'Zur Deutung der Kunst Caspar David Friedrichs', *Münchner Jahrbuch der bildenden Kunst*, XXVII, 1976, pp. 199–222.
'L'arbre aux corbeaux de Caspar David Friedrich', *Revue du Louvre*, XXVI, 4, 1976, pp. 275–90.
'Caspar David Friedrich et Carl Friedrich Schinkel', *Revue de l'Art*, XLV, 1979, pp. 9–20.
*Die Gemälde Caspar David Friedrichs im Schinkel-Pavillon*, 3rd revised edn, Berlin, 1980.
'Caspar David Friedrich und Philipp Otto Runge in Kopenhagen', *Text & Kontext*, XVIII, 1983, pp. 44–66.
BOIME, A., 'Caspar David Friedrich: *Monk by the Sea*', *Arts Magazine*, XCI, 3, 1986, pp. 54–63.
BRANDT, M., *Der Mönch am Meer. Caspar David Friedrich auf Rügen*, Husum, 1988.
BRINKMANN, B., 'Zu Heinrich von Kleists "Empfindungen vor Friedrichs Seelandschaft"', *Zeitschrift für Kunstgeschichte*, XLIV, 2, 1981, pp. 181–7.
BRION, M., 'Un grand romantique allemand: Caspar David Friedrich', *L'Oeil*, 256, 1976, pp. 14–19.
BRÖTJE, M., 'Die Gestaltung der Landschaft im Werk C. D. Friedrichs und in der holländischen Malerei des 17. Jahrhunderts', *Jahrbuch der Hamburger Kunstsammlungen*, XIX, 1974, pp. 43–88.
CHAPEAUROUGE, D. de, 'Die Kathedrale als modernes Bildthema', *Jahrbuch der Hamburger Kunstsammlungen*, XVIII, 1973, pp. 155–72.
'Bemerkungen zu Caspar David Friedrichs Tetschener Altar', *Pantheon*, XXXIX, 1, 1981, pp. 50–5.
DEBUYST, F., 'Bibliographie: C. D. Friedrich (1774–

1840), publications anniversaires', *Art d'Église*, LXI, 168–9, 1974, pp. 211–13.
DE PAZ, A., *Lo sguardo interiore. Friedrich o della pittura romantica tedesca*, Naples, 1986.
DOBRZECKI, A., *Die Bedeutung des Traumes für Caspar David Friedrich: eine Untersuchung zu den Ideen der Frühromantik*, dissertation, Ludwig-Maximilians-Universität, Munich, 1979.
DRESDEN, ALBERTINUM, *Caspar David Friedrich und sein Kreis*, exhibition catalogue, 1974.
DYRNESS, W. A., 'Caspar David Friedrich: the aesthetic Expression of Schleiermacher's Romantic Faith', *Christian Scholar's Review*, XIV, 4, 1985, pp. 335–46.
EIMER, G. (ed.), *Caspar David Friedrich: Auge und Landschaft. Zeugnisse in Bild und Wort*, Frankfurt am Main, 1974.
'Thomas Thorild und Caspar David Friedrich', *Jahrbuch der Hamburger Kunstsammlungen*, XIX, 1974, pp. 37–42.
(ed.), *Zur Dialektik des Glaubens bei Caspar David Friedrich*, Frankfurt am Main, 1982.
FIEGE, G., *Caspar David Friedrich in Selbstzeugnissen und Bilddokumenten*, Hamburg, 1977.
FÖRSTER, W., *Rügenlandschaft: Hommage à Caspar David Friedrich*, Berlin, 1975.
FORSTER-HAHN, F., 'Recent Scholarship on Caspar David Friedrich', *Art Bulletin*, LVIII, 1, 1976, pp. 113–16.
GÄRTNER, H., 'Caspar David Friedrich 1774–1974', *Bildende Kunst*, 8, 1974, pp. 366–72.
(ed.), *Caspar David Friedrich. Leben, Werk, Diskussion*, Berlin, 1977.
GEISMEIER, W., *Caspar David Friedrich*, Leipzig, 1973.
GROHN, H. W., 'Drei Denkmalsentwürfe von Caspar David Friedrich', *Niederdeutsche Beiträge zur Kunstgeschichte*, XVI, 1977, pp. 121–32.
GRÜTTER, T., *Melancholie und Abgrund. Die Bedeutung des Gesteins bei Caspar David Friedrich*, Berlin, 1986.
GRUNDMANN, G., 'Caspar David Friedrich: topographische Treue und künstlerische Freiheit, dargestellt an drei Motiven des Riesengebirgspanoramas von Bad Warmbrunn aus', *Jahrbuch der Hamburger Kunstsammlungen*, XIX, 1974, pp. 89–105.
HAESE, K., 'Der Realismus in der Landschaftsmalerei Caspar David Friedrichs', *Bildende Kunst*, 8, 1974, pp. 373–7.
HAMBURG, KUNSTHALLE, *Caspar David Friedrich, 1774–1840*, exhibition catalogue, 1974.
HANSEN, H. J., 'Das *Segelschiff* von Caspar David Friedrich: Anmerkungen zu einem von König Maximilian I. erworbenen Gemälde', *Zeitschrift für Kunstgeschichte*, XL, 1, 1977, pp. 63–5.
HEILMANN, C., *Caspar David Friedrich: 10 Gemälde*, Munich, 1984.
HINZ, B. (ed.), *Bürgerliche Revolution und Romantik. Natur und Gesellschaft bei Caspar David Friedrich*, Gießen, 1976.
HINZ, S., *Caspar David Friedrich in Briefen und Bekenntnissen*, 2nd revised and enlarged edn, Munich, 1974.
HOCH, K.-L., 'Caspar David Friedrich und Carl Gustav Carus in Dölzschen. Ein Beitrag zum Verhältnis Abbild und Sinnbild in der Romantik', *Sächsische Heimatblätter*, XXIV, 1978, pp. 111–14.

*Caspar David Friedrichs Frömmigkeit und seine Ehrfurcht vor der Natur, dargestellt an der Bergsymbolik der wiedererkannten böhmischen Bilder*, dissertation, Leipzig, 1981.
'Zu Caspar David Friedrichs bedeutendstem Manuskript', *Pantheon*, XXXIX, 3, 1981, pp. 229–30.
*Caspar David Friedrich – unbekannte Dokumente seines Lebens*, Dresden, 1985.
'Caspar David Friedrich, Ernst Moritz Arndt und die sogenannte Demagogenverfolgung', *Pantheon*, XLIV, 1986, pp. 72–5.
*Caspar David Friedrich in Böhmen. Bergsymbolik in der romantischen Malerei*, Stuttgart, 1987.
and CHAPEAUROUGE, D. de, 'Der sogenannte Tetschener Altar Caspar David Friedrichs', *Pantheon*, XXXIX, 4, 1981, pp. 322–6.
HOFMANN, W. (ed.), *Caspar David Friedrich und die deutsche Nachwelt*, Frankfurt am Main, 1974.
'Caspar David Friedrichs *Tetschener Altar* und die Tradition der protestantischen Frömmigkeit', *IDEA, Jahrbuch der Hamburger Kunsthalle*, I, 1982, pp. 135–62.
HOFSTÄTTER, H. H., *Caspar David Friedrich: Das gesamte graphische Werk*, Munich, 1974.
JENSEN, J. C., *Caspar David Friedrich: Leben und Werk*, Cologne, 1974.
JOACHIM, H., 'A Drawing by Caspar David Friedrich', *Bulletin of the Art Institute of Chicago*, LXX, 5, 1976, pp. 18–19.
KIEL, STIFTUNG POMMERN, *Caspar David Friedrich und sein Kreis. Gemälde und Graphik aus öffentlichen Sammlungen in Schleswig Holstein*, exhibition catalogue, 1975.
KOERNER, J. L., 'Borrowed Sight: the halted Traveller in Caspar David Friedrich and William Wordsworth', *Word & Image*, I, 2, 1985, pp. 149–63.
KRIEGER, P. (ed.), *Caspar David Friedrich: Die Werke in der Nationalgalerie Berlin, Staatliche Museen Preussischer Kulturbesitz*, Berlin, 1985.
KUNST, H. J., 'Die politischen und gesellschaftlichen Bedingtheiten der Gotikrezeption bei Friedrich und Schinkel', *Kritische Berichte*, II, 1974, pp. 120–9.
KYOTO, NATIONAL MUSEUM, *Caspar David Friedrich and his Circle*, exhibition catalogue, 1978.
LEIGHTON, J., REEVE, A., and BURNSTOCK, A., 'A *Winter Landscape* by Caspar David Friedrich', *National Gallery Technical Bulletin*, 13, London, 1989, pp. 39, 44–51.
LEIPZIG, MUSEUM DER BILDENDEN KÜNSTE, *Caspar David Friedrich und sein Kreis*, exhibition catalogue, 1974.
LENINGRAD, HERMITAGE, *Kaspar David Fridrikh i romanticeskaja zivopis ego vremeni. Katalog vremennoj vystavki*, exhibition catalogue, 1974.
LICHTENSTERN, C., 'Beobachtungen zum Dialog Goethe – Caspar David Friedrich', *Baltische Studien*, new series, LX, 1974, pp. 75–100.
LIEBMANN, M. J., 'Joukovsky als Zeichner. Neues zur Frage "C. D. Friedrich und W. A. Joukovsky"', *Jahrbuch der Hamburger Kunstsammlungen*, XIX, 1974, pp. 106–16.
MÄRKER, P., *Geschichte als Natur. Untersuchungen zur Entwicklungsvorstellung bei Caspar David Friedrich*, dissertation, Kiel, 1974.
MILLER, P. B., 'Anxiety and Abstraction: Kleist and

Brentano on Caspar David Friedrich', *Art Journal*, XXXIII, 3, 1974, pp. 205–10.

MITCHELL, T. F., *Philipp Otto Runge and Caspar David Friedrich: A Comparison of their Art and Theory*, dissertation, Indiana University, 1977.

'From Vedute to Vision: the Importance of Popular Imagery in Friedrich's Development of Romantic Landscape Painting', *Art Bulletin*, LXIV, 3, 1982, pp. 414–23.

'Caspar David Friedrich's *Der Watzmann*: German Romantic Landscape Painting and historical Geology', *Art Bulletin*, LXVI, 3, 1984, pp. 452–64.

'What mad pride! Tradition and Innovation in the Ramdohrstreit', *Art History*, vol. 10, 3, 1987, pp. 315–27.

'Bound by Time and Place: the Art of Caspar David Friedrich', *Arts Magazine*, LXI, 3, 1986, pp. 48–53.

MÖBIUS, F., 'Eldenas Erbewerte. Versuch einer ikonologischen Bestimmung', Supplement to *Bildende Kunst*, XXVII, 8, 1979, pp. 1–6.

*Caspar David Friedrichs Gemälde 'Abtei im Eichwald' und die frühe Wirkungsgeschichte der Ruine Eldena bei Greifswald*, Berlin, 1980.

MOSCOW, PUSHKIN STATE MUSEUM OF FINE ARTS, *Kaspar David Fridrikh (1774–1840) i ego sovremenniki. Akvareli i risunki iz sobranija GMII*, exhibition catalogue, 1975.

MOSENEDER, K., 'C. D. Friedrichs *Kreidefelsen auf Rügen* und ein barockes Emblem in der romantischen Malerei', *Zeitschrift für Kunstgeschichte*, XLVI, 3, 1983, pp. 313–20.

NEIDHARDT, H.-J., 'Caspar David Friedrich und Ludwig Richter', *Staatliche Kunstsammlungen Dresden: Jahrbuch*, 1970–71, 1973, pp. 99–116.

'Einige Beispiele zeitgenössischer Friedrich-Rezeption', *Beiträge und Berichte der Staatlichen Kunstsammlungen Dresden*, 1972–5, pp. 13–21.

*Die Malerei der Romantik in Dresden*, Leipzig, 1976.

'Friedrichs *Wanderer über dem Nebelmeer* und Carus' *Ruhe des Pilgers*: zum Motiv des Gipfelerlebnisses in der Romantik', in *Ars auro prior. Studia Ioanni Bialostocki sexagenario dicata*, Warsaw, 1981, pp. 607–12.

'Caspar David Friedrichs Ansichten der Ruine des Brühlschen Belvedere zu Dresden', *Jahrbuch der Staatlichen Kunstsammlungen Dresden*, XVI, 1984, pp. 75–80.

'Joseph Anton Koch und Caspar David Friedrich: Wege deutscher Landschaftsmalerei um 1800', *Berner Kunstmitteilungen*, 238–40, 1985, pp. 1–11.

OHARA, M., *Demut, Individualität, Gefühl. Betrachtungen über C. D. Friedrichs kunsttheoretische Schriften und ihre Entstehungsumstände*, dissertation, Berlin, 1983.

'Über die sogenannte *Grosse Gehege* Caspar David Friedrichs', *Zeitschrift für Kunstgeschichte*, XLVII, 1, 1984, pp. 100–17.

PARIS, CENTRE CULTUREL DU MARAIS, *Caspar David Friedrich: le tracé et la transparence*, exhibition catalogue, 1984.

PLATTE, E., *Caspar David Friedrich: Religiöse Landschaft*, Bielefeld, 1975.

PRAUSE, M., '*Wrack im Mondschein*. Ein neuentdecktes Bild von Caspar David Friedrich', in *Festschrift für Otto von Simson*, Berlin, 1977, pp. 458–63.

RAENSCH-TRILL, B., 'Caspar David Friedrichs Landschaftsbilder auf dem Hintergrund der ästhetischen Theorie Kants', in *Kunst und Erziehung* [Festschrift for Ernst Strassner], Göttingen, 1975, pp. 119–33.

RAUTMANN, P., 'Caspar David Friedrich: zu seiner geschichtlichen Stellung', *Tendenzen*, LXVI, 99, 1975, pp. 48–52.

*Caspar David Friedrich. Landschaft als Sinnbild entfalteter bürgerlicher Wirklichkeitsaneignung*, Frankfurt am Main, 1979.

'Winter-Zeiten: C. D. Friedrichs und Ph. O. Runges künstlerische Konzeption und Praxis. Denk- und Sehanstosse für heute', *Kritische Berichte*, IX, 6, 1981, pp. 38–64.

REITHAROVÁ, E., 'Caspar David Friedrich (1774–1840), *Umeni*, XXIV, 5, 1976, pp. 385–406.

'Bohemian Landscapes in the Works of Caspar David Friedrich', *Konsthistorisk Tidskrift*, XLVII, 1, 1978, pp. 39–53.

and SUMOWSKI, W., 'Beiträge zu Caspar David Friedrich', *Pantheon*, XXXV, 1, 1977, pp. 41–50.

RUHMER, E., *Caspar David Friedrich: Meereslandschaften*, Munich and Zurich, 1978.

SANDNER, I., 'Besonderheiten der Unterzeichnung auf Gemälden der Romantik am Beispiel in Dresden tätiger Maler', in H. Althöfer (ed.), *Das 19. Jahrhundert und die Restaurierung. Beiträge zur Malerei, Maltechnik und Konservierung*, Munich, 1987, pp. 164–75.

SCHADE, W., 'Eine Sepiazeichnung Caspar David Friedrichs: Neuerwerbung des Berliner Kupferstichkabinetts', *Forschungen und Berichte, Staatliche Museen zu Berlin*, XXIII, 1983, pp. 99–101.

SCHMIED, W., *C. D. Friedrich*, Cologne, 1975.

SCHNEIDER, N., 'Natur und Religiosität in der deutschen Frühromantik: zu Caspar David Friedrichs *Tetschener Altar*', *Kritische Berichte*, I, 1973, pp. 60–98.

SCHOTT, A., 'Das Kopenhagener Stammbuch des Caspar David Friedrich', *Greifswald-Stralsunder Jahrbuch*, XI, 1977, pp. 133–60.

(ed.), *Die Friedrich-Sammlung des Greifswalder Museums: Handzeichnungen, Druckgraphiken*, Greifswald, 1977.

SCHULZE, U., *Ruinen gegen den konservativen Geist. Ein Bildmotiv bei Caspar David Friedrich*, Worms, 1987.

SCHUSTER, P. K., 'Schinkel, Friedrich und Hintze. Zur romantischen Ikonographie des deutschen Nationalgefühls', *Zeitschrift des deutschen Vereins für Kunstwissenschaft*, XXXV, 1–4, 1981, pp. 18–35.

SÉRULLAZ, A., 'Un dessin de Caspar David Friedrich', *Revue du Louvre*, XXV, 1, 1975, pp. 55–6.

SIEGEL, L., 'Synaesthesia and the Paintings of Caspar David Friedrich', *Art Journal*, XXXIII, 3, 1974, pp. 196–204.

and LEVITINE, G., *Caspar David Friedrich and the Age of German Romanticism*, Boston, 1978.

SIMSON, O. VON, 'Über die symbolische Bildstruktur einiger Gemälde von Caspar David Friedrich', in *Ars auro prior. Studia Iohanni Bialostocki sexagenario dicata*, Warsaw, 1981, pp. 597–605.

*Der Blick nach Innen. Vier Beiträge zur deutschen Malerei des 19. Jahrunderts*. Berlin, 1986.

SPETH, K., 'Caspar David Friedrich '75. Versuch eines Querschnitts durch die Caspar-David-Friedrich-Literatur der letzten Jahre', *Aurora*, XXXVI, 1976, pp. 75–106.

STOCKHOLM, NATIONALMUSEET, *Romantiken i Dresden: Caspar David Friedrich och hans Samtida 1800–1850*, exhibition catalogue, 1981.

STOELZEL, M., 'Caspar David Friedrich und seine Transparentmalerei mit Musikbegleitung', *Baltische Studien*, LXI, 1975, pp. 75–80.

SULLIVAN, E. J., 'Caspar David Friedrich und das landschaftliche Stimmungsbild', *Du*, XXXVIII, 445, March 1978, pp. 37–43.

SUMOWSKI, W., *Katalog einer Sammlung von Zeichnungen Caspar David Friedrichs*, Tübingen, 1973.

*Caspar David Friedrich. Sein Werk im Urteil von Zeitgenossen*, Herrsching, 1976.

TOKYO, NATIONAL MUSEUM OF MODERN ART, *Caspar David Friedrich and his Circle*, exhibition catalogue, 1978.

TRAEGER, J. (ed.), *Caspar David Friedrich*, Munich, 1976.

'Philipp Otto Runge und Caspar David Friedrich', in W. Hofmann and H. Hohl (ed.), *Runge: Fragen und Antworten*, Munich, 1979, pp. 96–114.

UNVERFEHRT, G., *Caspar David Friedrich*, Munich, 1984.

VAUGHAN, W., *German Romantic Painting*, London and New Haven, 1980.

VIGNAU-WILBERG, P., 'Caspar David Friedrichs *Kreidefelsen auf Rügen*: Notizen zur Landschaftsdarstellung der Romantik', *Münchner Jahrbuch der bildenden Kunst*, XXXI, 1980, pp. 247–58.

'Zur Deutung von Caspar David Friedrichs *Kreidefelsen auf Rügen*', *Mitteilungen der Gesellschaft für Vergleichende Kunstforschung in Wien*, XXXIV, 3, 1982, pp. 1–6.

VINES, E. L., *Landscape through Literature: Caspar David Friedrich and Three German Romantic Writers (Tieck, von Kleist, von Eichendorff)*, dissertation, Harvard University, 1987.

VOGEL, G.-H., 'Caspar David Friedrich ja Ateljeekuvan Ongelma', *Taide*, XXVII, 4, 1986, pp. 50–5.

WALTHER, A., *Caspar David Friedrich*, Berlin, 1983.

WEICHARD, J., 'Neuerwerbungen des Herzog-Anton-Ulrich-Museums. Drei Zeichnungen von Caspar David Friedrich', *Weltkunst*, XLVII, 15, 1977, pp. 150–1.

WINKLER, G., 'Ein Nachtrag zu Caspar David Friedrich', *Wissenschaftliche Zeitschrift der Greifswalder Ernst-Moritz-Arndt-Universität. (Gesellschafts-und Sprachwissenschaftliche Reihe)*, XXVIII, 1–2, 1979, pp. 119–21.

*Wissenschaftliche Zeitschrift der Ernst-Moritz-Arndt-Universität Greifswald. Sonderband. Caspar David Friedrich. Bildende Kunst zwischen der Französischen Revolution von 1789 und der bürgerlich-demokratischen Revolution von 1848*, Greifswald, 1974.

ZASKE, N., 'Das Motiv der Stadt bei Caspar David Friedrich', *Bildende Kunst*, 8, 1974, pp. 378–82.

ZEITLER, R., 'Caspar David Friedrich', *Paletten*, 4, 1975, pp. 12–15.

ZÜRICH, KUNSTHAUS, *Zeichnungen der Romantik aus der Nationalgalerie Oslo: Caspar David Friedrich, Johann Christian Dahl, August Heinrich*, exhibition catalogue, 1985.

*Gemälde der deutschen Romantik aus der Nationalgalerie Berlin, Staatliche Museen Preussischer Kulturbesitz: Caspar David Friedrich, Karl Friedrich Schinkel, Karl Blechen*, exhibition catalogue, 1985.